IMAGES
of Rail

MONTGOMERY COUNTY
TROLLEYS

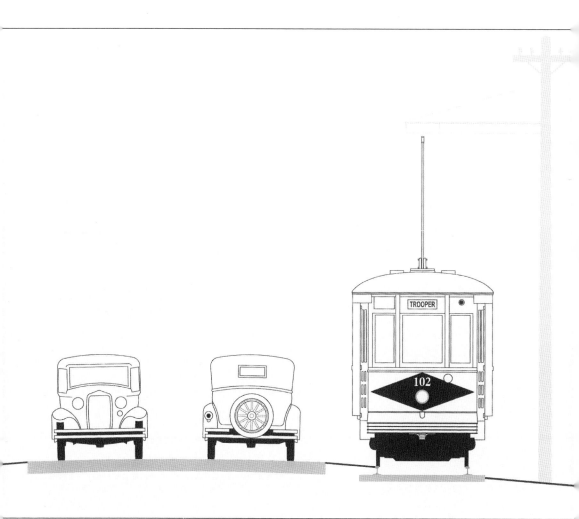

Montgomery County's trolley tracks often ran alongside public roads, as depicted in this scaled drawing based on 1920s Pennsylvania Department of Highways standards. While representative of many locations throughout the county, this drawing shows Sandy Hill Road in Plymouth Township with a Reading Transit & Light Company (RT&L) streetcar on the trolley track. In the 1920s, many of RT&L's trolleys were painted a light cream color with bold red diamonds on both ends. Car 102 survives today at the Electric City Trolley Museum in Scranton, Pennsylvania. (Drawing by the author.)

ON THE COVER: Reading Transit & Light trolley 508 moves away from the camera, northbound on Dekalb Street in Norristown between Lafayette Street and Main Street in 1930. The trolley has just crossed the electrified tracks of the Pennsylvania Railroad Schuylkill Division, which would in a few short years be removed from Lafayette Street and be rerouted onto a new bridge over Dekalb Street (today utilized by the Schuylkill River Trail). The wire mesh along the overhead trolley wire was placed there to provide the trolley with uninterrupted power in the event the trolley pole slipped off the wire. After the Norristown trolley lines became bus routes in 1933, this trolley would serve in the city of Reading for many more years. (Courtesy of Andrew W. Maginnis.)

IMAGES
of Rail

MONTGOMERY COUNTY
TROLLEYS

Mike Szilagyi
Foreword by Andrew W. Maginnis

ARCADIA
PUBLISHING

Published by Arcadia Publishing
Charleston, South Carolina

Printed in the United States of America

Library of Congress Control Number: 2017957476

For all general information, please contact Arcadia Publishing:
Telephone 843-853-2070
Fax 843-853-0044
E-mail sales@arcadiapublishing.com
For customer service and orders:
Toll-Free 1-888-313-2665

Visit us on the Internet at www.arcadiapublishing.com

This volume is dedicated to the memory of the late Harry Foesig (1897–2003). After retirement from his career as an industrial designer, Harry turned his bright wit, enthusiasm, and attention to detail to telling the story of Montgomery County's trolleys. The result was his 1968 book *Trolleys of Montgomery County Pennsylvania*, still the authoritative text on the subject. Without the foundation he laid, the book you hold in your hands would not have been written. Harry had a wonderful way of sharing with others his love of the trolleys that were, in his words, "colorful, experimental, groaning monsters that rocketed along the twisted rails of the past." (Courtesy of Harry's granddaughter Sherry Stella.)

CONTENTS

FOREWORD

It all started when I found myself sitting in the aisle of an Old York Road trolley. I was riding with my parents, probably about four years old, and I thought it was great to have a seat all to myself. In the years before the Old York Road line quit, the tracks had crept badly out of alignment. The big green trolleys stayed on the track, but they would really jolt from side to side. That day, the rocking was so bad it threw me clear off the wooden bench seat, and a memory was born.

Around that time, my cousin Frank gave me a hand-me-down green Lionel No. 8 toy trolley, and that sealed the deal. I was hooked. I still remember the spring day in 1947 when my father and I laid eyes on the first streamlined trolley gliding down the avenue near our home in Germantown. Compared to the creaking relics we were used to riding, the new streetcar was a thing of beauty.

Then there were the rides on the fast Liberty Bell high-speed line. My mother and I would ride the Limited when she visited her friends in Allentown. Looking out the wraparound back windows, we'd watch the Pennsylvania countryside zoom past, all the while relaxing in comfortable armchairs. Once at her friends' house, I'd always offer to walk their dog, knowing the Gordon Street trolley barn was within walking distance. Well, maybe it was more like hiking distance. That poor little dog was ready for a nap every time we got back.

Years later, working for the Pennsylvania Department of Highways, I got access to wonderful old blueprints that traced the long-gone trolley lines. My lifelong friend Harry Foesig made good use of these when he drafted the maps for his *Trolleys of Montgomery County Pennsylvania* book. Harry and I spent many Thursday nights at his North Wales studio poring over old maps and plans, enjoying good wine and cigars, and remembering the old times.

Fifty years after Harry's work was published, this book picks up where his leaves off. Photographs from Harry's collection and mine, and many others besides, were carefully selected to illustrate this story of Montgomery County's trolleys. Enjoy the ride.

—Andrew W. Maginnis
Lansdale, Pennsylvania

ACKNOWLEDGMENTS

First and foremost, thanks are due my friend Andrew W. Maginnis, who kindly opened up his treasure trove of historical photographs, documents, and firsthand memories. It was Andy who introduced me to the informal constellation of individuals who have for so many years safeguarded the various chapters of this story, saving them from disappearing into the mists of the past.

I would like to express my gratitude to Harry Foesig's family, especially his granddaughter Sherry Stella.

Thanks go to Stanley F. Bowman Jr., who generously shared his collection with me and meticulously cleaned some of my less-than-perfect photo scans. I encourage anyone interested in Montgomery County to seek out Stan's wonderful book, *The Trolleys of Pottstown, PA*. It's a terrific history, full of firsthand memories, and is beautifully illustrated besides.

Special thanks are owed William J. McKelvey Jr. Some of the best scenes in chapter 3 are photographs McKelvey gathered for two volumes on the Lehigh Valley Transit Company—one published, one not—that he donated to the Railways to Yesterday Library in Allentown.

Thanks are due Doug Peters, longtime curator of the Railways to Yesterday Library; Leslie Lowell-Griffin and Susan Caughlin of the Worcester Historical Society; the late Pastor Paul M. Lederach; Glenn Isett of the Lower Pottsgrove Historical Society; Dr. Richard L. Allman for making available hundreds of superb prints that he painstakingly developed from negatives; Dick Shearer and Steve Moyer of Lansdale Historical Society; Jerry Chiccarine; Bob Sauer; Joe Frank the piano man; Ed Ziegler of the Historical Society of Montgomery County; Steve Worthington and Ray Stahl of the Lower Moreland Historical Association; Dick Short; Phyllis Byrne of the North Wales Historic Commission; Bob Wood of the New Hanover Township Historical Society; Leon Florentino of Harleysville; Bruce Bente; the Wismer family; James Brazel of the Tredyffrin Easttown Historical Society; Bruce Clark; David Rowland of the Old York Road Historical Society; Martha Capwell-Fox of the National Canal Museum; Lisa Minardi of Ursinus College; David Sadowski and Jeff Wien for tracking down photographs of Libertyliners in Milwaukee; Ed Skuchas; Jerry Francis of the Lower Merion Historical Society; Pennsylvania Department of Transportation District Six archivist Chandra Scott; Joe Eckhardt and Lawrence Greene of Montgomery County Community College; the Mennonite Heritage Center; the Pottstown Historical Society; the Skippack Historical Society; and the Pennsylvania Trolley Museum.

I have made a good-faith effort at accurate attribution of all photographs. If any errors were made, they were inadvertent.

Additional materials—including an index, a bibliography, and georeferenced photo locations—can be accessed at the website www.montgomerycountytrolleys.com.

INTRODUCTION

Montgomery County, Pennsylvania, was incorporated in 1784, created by separating a roughly 500-square-mile outlying tract of Philadelphia County. With its county seat at Norristown, Montgomery County was centered roughly midway between three major Pennsylvania cities: Philadelphia to the east, Reading to the west, and Allentown to the north.

Because of its location well inland of seaports and navigable waterways, commerce and development were slow to reach the county. A poor network of roads, many of them only modestly improved Lenape Indian trails, made travel and the movement of goods difficult and time-consuming. This would begin to change in the 1810s with the construction of the Schuylkill Navigation canal system. After its official opening between Reading and Philadelphia in 1824, the tremendous tonnage of goods and raw materials such as anthracite coal, drawn by mules at the water's edge, enabled the growth of Schuylkill River towns including Pottstown, Royersford, Norristown, and Conshohocken.

The benefits bestowed by the inland waterway would be eclipsed by the next big thing: steam railroads. Powered by coal rather than by animals and able to operate through the winter, when ice brought canal traffic to a standstill, the railroads brought commerce to places beyond the reach of the canal.

The first railroad in Montgomery County was the Philadelphia & Columbia Railroad (P&C). After ascending the inclined plane in Fairmount Park at Belmont, the P&C followed a meandering route that included Cynwyd and Ardmore in Lower Merion Township. Constructed between 1829 and 1834, the 82-mile route linked Philadelphia with Columbia on the Susquehanna River, then considered the gateway to the west.

The Philadelphia, Germantown & Norristown Railroad (PG&N) was constructed along the north bank of the Schuylkill River, reaching Norristown in 1835. Three years later, the Philadelphia & Reading Railroad (P&R) reached as far downriver as Bridgeport on its way to Philadelphia. Both the PG&N and P&C were constructed at a time when steam locomotive technology was experimental and expensive. In the earliest years, short trains of animal-drawn cars on those railroads were not unheard of. By 1844, all trains were steam powered, and P&R trains were hauling more coal annually than competing Schuylkill Navigation canalboats.

In the 1850s, the North Pennsylvania Railroad was completed between Philadelphia and Bethlehem, serving Ambler, Lansdale, Hatfield, and Souderton. Beginning in the 1860s, the Perkiomen Railroad connected the towns of Collegeville, Schwenksville, and Pennsburg. The construction of minor railroads branching off the main lines enabled the growth of towns such as Hatboro. Finally, in the 1880s, the Pennsylvania Railroad completed two major improvements: the Schuylkill Division, which generally paralleled the Reading Railroad, and the Trenton Cut-Off, which sliced diagonally across the county from Upper Merion to Lower Moreland.

Although many towns did benefit from the emerging railroad network, large swaths of Montgomery County lay beyond the reach of the railroads and therefore were still dependent on rough, unpaved roads. Heavy rains and spring thaws would leave many roads virtually impassable. Private turnpike companies assumed ownership and maintenance of some longer-distance roads in the county, with the understanding that they would plow revenues collected at tollbooths back into improving the roads. This solution met with limited success. Tolls were unpopular—even bicyclists had to pay—and complaints over poor road conditions persisted. Many of Montgomery County's former toll roads are still referred to as pikes over a hundred years after they were freed and the tollhouses removed.

It did not make economic sense for the steam railroads to build a dense network capable of serving each town and village that dotted what was then a primarily agricultural landscape. This was in part due to constraints imposed by the physics of a single powerful locomotive pulling long strings of railcars. Steam railroad surveyors needed to lay out tracks that were as close to level and as near to straight as possible: only modest inclines and gradual curves were viable. Therefore, building steam railroads through the uneven terrain of Montgomery County required tremendous amounts of capital to acquire right-of-way, move earth and rock, erect bridges, and in some places bore tunnels. Most steam railroads were financed by investors who saw the potential in connecting major population centers well beyond the boundaries of the county. Serving the towns along the line came as an afterthought.

The advent of the electric railway would bring a new dynamic. Electric trolley cars, usually running as single cars but sometimes linked together in trains, negotiated curves and climbed grades that steam-hauled trains could not and at a fraction of the cost. With the installation of overhead wire, early electric cars could even operate on the horsecar tracks already in place on urban streets in such places as Norristown. Rather than purchase exclusive rights-of-way as steam railroads did, trolley companies often opted to simply lay their tracks in or alongside roadways, within the public right-of-way. The new electric railways improved transportation within population centers while also pushing into new territories not previously served by rail.

The first electric trolleys to enter service in Montgomery County were not those that would occupy the streets of the county seat of Norristown but rather the industrial borough of Pottstown, some 20 miles up the Schuylkill River. On Thursday, June 15, 1893, trolleys of the Pottstown Passenger Railway Company inaugurated regular service on High Street between Moser Road and the village of Stowe just west of town. Within weeks, service would extend east into Lower Pottsgrove Township and the amusements at Sanatoga Park, an attraction owned by the company.

Trolley service in Norristown began shortly after the successful debut of electric cars in Pottstown. On July 21, 1893, electric trolleys replaced horse-drawn railcars on Citizens Passenger Railway Company's Main Street line and on the Stanbridge Street line to the state hospital. The Norristown Passenger Railway Company quickly followed suit, but extension of its Dekalb Street line across the Schuylkill River into Bridgeport was met with serious opposition.

The trouble stemmed not from crossing the river—permission had been granted to place tracks and wires inside the old wooden covered bridge—but rather from the at-grade crossing of the Reading Railroad. Despite a court order allowing the tracks to cross one another, the Reading Railroad sent work crews to the Dekalb Street crossing to confront the trolley construction crews and to dismantle their work. The trolley and railroad companies took turns positioning their machines over the disputed crossing, with the trolleys only backing off as trains approached. When a Reading Railroad work locomotive intentionally rammed a trolley, shoving it off the rails, the Reading's dispatcher was arrested, as was a Reading supervisor vandalizing trolley work on the Bridgeport side.

The crossings were eventually settled, but the result was that the trolley companies would go to great lengths, often literally, to avoid grade crossings with the railroads as they planned their lines. An 1897 photograph of a "trolley war" in Collegeville that pitted men hired by the Reading Railroad against a trolley construction crew can be viewed on page 30 of this book. In some places, expensive bridges would be built, but such solutions were not always practical. And even when a trolley company did go to the effort of erecting a bridge over a railroad, that did not always avert conflict. During construction of the Allentown–to–Chestnut Hill trolley, the Reading Railroad sent a work gang to North Wales to distract trolley workmen while its foreman threw a weighted rope over the trolley's not-yet-energized high-tension wire, hauled it down, and severed it with a machete.

An extension of Citizens Passenger Railway's Main Street line from Norristown's West End to Egypt Road at Jeffersonville opened for service in March 1894. As the track left the borough and entered Norriton Township at Forrest Avenue, it swung to the left and continued in the shoulder of the highway rather than in the center. This would be common practice throughout the county:

trolley tracks in the middle of the road in town and on the side of the road between towns. Trolleys ran in both directions on the single track, on one side of the road, with alternating trolley cars "bucking traffic" (in today's parlance). The drawing on page 2 illustrates this arrangement. Electric signals and frequent passing sidings were provided so that opposing trolleys could safely pass one another. Signals did prevent collisions most of the time, but on rare occasions, tampering or human error resulted in incidents ranging from merely inconvenient to disastrous.

By Pennsylvania law, the trolley companies did not have the right of eminent domain and therefore could not condemn property to acquire right-of-way. In addition, if the trolley was to be built on the side of the road, the permission of the property owner fronting the road was required, even if the trolley fit entirely within the public right-of-way. The end results were trolley tracks that seemed to arbitrarily cross from one side of the road to the other, depending on how amenable the opposite property owners were at the time the line was constructed. One trolley line, the Lehigh Valley Transit Company's Chestnut Hill division, was forced to cross and recross the highway no less than 10 times between North Wales and Flourtown. Such crossings were not deemed a serious problem early on, but as highway traffic volumes and speeds increased, so did the frequency and severity of collisions.

In 1895, People's Traction Company completed its trolley line from Philadelphia through Jenkintown to company-owned Willow Grove Park. From the beginning, trolley traffic was heavy enough to warrant tracks on both sides of Old York Road (an arrangement not found elsewhere in the county). The tracks transitioned to the center of the toll road only as they passed through the village of Ogontz and the borough of Jenkintown. In 1898, Bucks County Railway Company completed another trolley line to Willow Grove, a single track in the shoulder of Easton Road from Doylestown.

In 1895, electric cars began running between Norristown and Northwestern Avenue just outside the Chestnut Hill neighborhood of Philadelphia. Prior to its 1894 electrification, the Barren Hill–to–Wissahickon line, built by the Manayunk & Roxborough Inclined Plane and Railway Company, had been a slow horse-drawn car line on Ridge Avenue.

Most of Montgomery County's trolley lines were built in the decade between 1895 and 1905. Mergers and takeovers assembled ever larger networks. For example, Norristown's Schuylkill Valley Traction Company (SVT) was formed by leasing the following underlying companies: the Norristown Passenger Railway Company; Citizens Passenger Railway Company; Conshohocken Railway Company; Ambler Electric Railway Company (which was never built); Collegeville Electric Street Railway Company; Roxborough, Chestnut Hill & Norristown Traction Company; and the Trappe & Limerick Street Railway Company. In 1910, the entire SVT was in turn absorbed by the Reading Transit Company, operator of an extensive trolley network stretching from beyond Reading into Philadelphia. Finally, in 1913, Reading Transit Company became Reading Transit & Light Company. Ironically, RT&L's underlying entities would briefly re-emerge as the trolleys became unprofitable at the onset of the Great Depression. To cut its losses, RT&L simply terminated the leases.

During 1899 and 1900, a trolley line was constructed from Telford, through Souderton, Hatfield, and Lansdale, to North Wales named the Inland Traction Company. Neither Telford nor North Wales was its intended destination. Rather, the line was a link in Allentown transit magnate Albert L. Johnson's bold vision for an electric railway connecting Allentown, Philadelphia, and New York City. Preparations for the New York line were dropped after Johnson's untimely death at age 41, but plans for the Philadelphia line were pressed forward, and in 1902, Lehigh Valley Transit Company inaugurated trolley service over the Liberty Bell Route between Allentown and Erdenheim in Springfield Township. At Erdenheim, passengers transferred to Philadelphia Rapid Transit Company (PRT) streetcars to continue their journey into the city. An amusement park named White City was built adjacent to the Erdenheim trolley terminal, attracting more fare-paying passengers to both systems' trolleys.

In 1902, a trolley line between Lansdale and Norristown was completed by the Montgomery Traction Company. This line would play a major role in the establishment of the county's preeminent

high-speed line a decade later, as Montgomery Traction would be bought out by Lehigh Valley Transit (LVT) as the latter sought a more direct route to Philadelphia.

This was also the year that PRT purchased the Doylestown–to–Willow Grove line and built a branch line to serve Hatboro.

Montgomery County Rapid Transit Company's line from Norristown through Skippack to Harleysville would emerge in stages beginning in 1907. Its intended destination in Souderton was never reached, and a highly anticipated branch serving the upper Perkiomen Valley never materialized. Despite the similar names, this company was not affiliated in any way with Montgomery Traction Company. Not surprisingly, newspaper editors often referred to one when meaning the other. This situation would be made worse in coming years after Montgomery County Rapid Transit Company was reorganized as Montgomery Transit Company.

Trolley traffic on the Old York Road line to Willow Grove Park was so heavy—on busy days, a trolley was scheduled every 30 seconds—that in 1905, a second double-track trolley line was constructed between Philadelphia and the park. The new line's promoters included real estate developer W.T.B. Roberts, whose projects along the line, notably Glenside, would become classic streetcar suburbs. In 1905, PRT constructed an elaborate multitrack trolley terminal at Willow Grove, replacing the original trolley line that looped around the entire park.

Long-awaited legislation authorizing trolleys to carry freight was passed by the Pennsylvania Legislature and signed by Gov. Edwin Stuart in 1907. The trolley's fast, affordable delivery service can in retrospect be thought of as the FedEx of its day.

The year 1912 was an auspicious one for Montgomery County's trolleys. December 12, 1912, was the first day for Lehigh Valley Transit Company's high-speed electric trolley service to Allentown on a new line originating in Upper Darby rather than at Erdenheim. The original zigzag side-of-the-road line built 10 years prior was bypassed and a new single-track railroad-style line built instead. Palatial trolley cars, advertised as "The Finest Electric Trains in the World," hurried between towns at mile-a-minute speeds.

In 1914, the Phoenix Water Power Company's hydroelectric plant at Lock 60 on the Schuylkill Navigation in Upper Providence Township went online, its three turbines generating clean power for Reading Transit & Light Company trolleys.

The 1920s marked the beginning of the end for the trolleys. When the Commonwealth of Pennsylvania began in earnest to use tax revenues to pave highways, the benefit went to motor vehicle owners (who at the time comprised a small minority of the population). The higher speeds encouraged by 18-foot-wide concrete roads with no shoulders left pedestrians, bicyclists, and transit users at a distinct disadvantage. In 1925, the first line to scrap its trolleys was Montgomery Transit Company. The next year, LVT abandoned its North Wales–to–Erdenheim line (this not long after LVT had spent a small fortune relocating its tracks on Bethlehem Pike due to a state highway paving project). RT&L's Pottstown-to-Boyertown line and the Harmonville Tripper would follow suit in 1927.

The Great Depression only accelerated the trend. In 1931, the Doylestown–to–Willow Grove line folded, as did the RT&L's Norristown–to–Chestnut Hill service. The year 1933 marked the end of the entire Norristown-based trolley system, which was replaced by buses of the new Schuylkill Valley Lines. Trolley service in Pottstown ended in 1936. In 1940, the original Willow Grove trolley on Old York Road became a bus line. By the 1950s, only three lines remained. Lehigh Valley Transit Company's famed Liberty Bell Limited trolleys were replaced with slow buses in 1951. On June 8, 1958, the Glenside line to Willow Grove ended. The last trolley from Willow Grove, no. 2134, serves today as an ice-cream stand on Germantown Avenue in Mount Airy. The Ardmore trolley ceased running in 1966.

With car-free living recognized as a desirable lifestyle today, it is worth remembering that there was a time when Montgomery County was served by a comprehensive 140-mile network of electric trolley lines. As we sit in our cars waiting for another traffic light to change, it is worth taking a moment to ponder the choices we have lost.

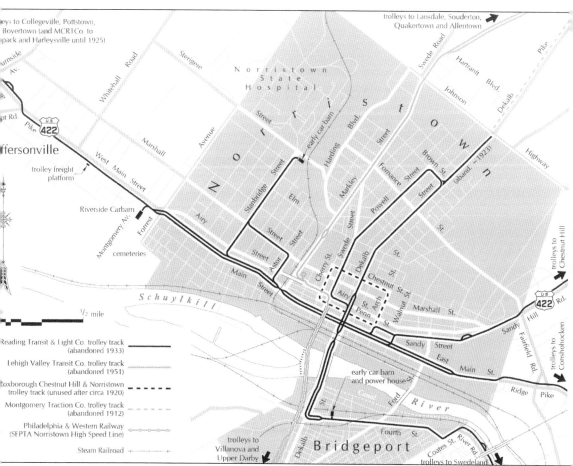

The county seat of Norristown was home to the densest network of trolley lines in the county. Schuylkill Valley Traction Company's suburban network reached out like the fingers of a giant hand to Conshohocken, Bridgeport, and Swedeland, Chestnut Hill and Manayunk, Collegeville and points west, and short routes within the borough. For a brief time, trolleys to Skippack and Harleysville shared the busy rails on Main Street. Finally, in the 1950s, the world-class high-speed cars of the Lehigh Valley Transit Company closed out trolley service in Norristown. Trolleys no longer run on the Philadelphia & Western (P&W) Railway, but rapid transit trains still carry passengers on that line, today referred to as the Norristown High Speed Line. (Drafted by the author.)

One

POTTSTOWN, RINGING ROCKS, GILBERTSVILLE
FIRST TROLLEYS IN THE COUNTY

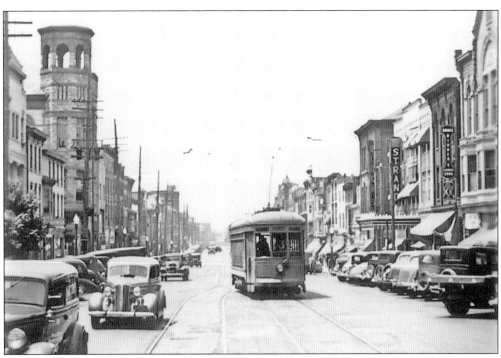

Montgomery County's second-largest town was the first to have electric trolleys. The Pottstown Passenger Railway's (PPR) streetcars connected Stowe, west of town, with Sanatoga and Linfield to the east. This June 1936 photograph, taken from the back window of an eastbound trolley, captures a westbound car at the passing siding on High Street between Evans Street and Charlotte Street in downtown Pottstown. (Courtesy of Stanley F. Bowman Jr.)

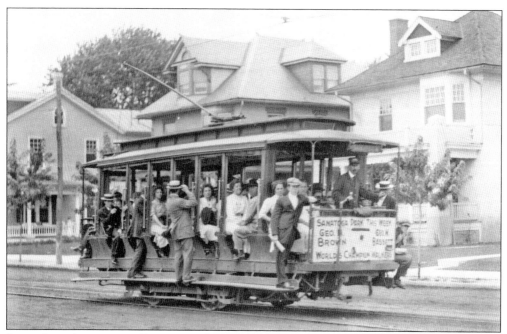

In good weather, open trolleys were a favorite of passengers, but the early four-wheeled versions could hold only so many. As long as the fare was paid, conductors did not stop passengers from sitting or standing on the running boards outside the car. This trolley, seen on High Street between Keim Street and Price Street, is carrying a crowd bound for Sanatoga Park. (Courtesy of the Pottstown Historical Society.)

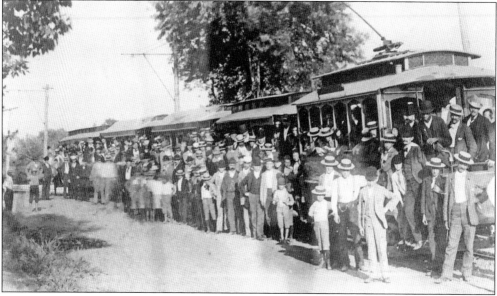

A handwritten inscription in the margin of this photograph states that no less than 492 passengers were hauled on this trolley and the four trailers it is pulling. The occasion was a well-attended 1890s game at the Pottstown Base Ball Grounds on High Street near today's Rosedale Drive. Trolleys were not designed to haul a train such as this, and one wonders if the electric motors beneath the lead car survived to serve another day. (Courtesy of the Pottstown Historical Society.)

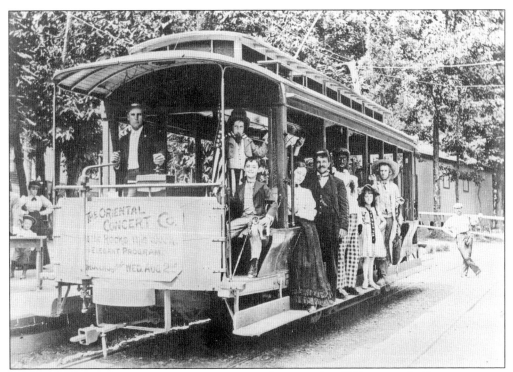

American flags and patriotic costumes are in evidence in this 1890s view of a Pottstown open car. The placard on the dash advertises the Oriental Concert Company's upcoming elegant program at Ringing Rocks Park and an August picnic for grocers. Opinions differ as to whether the location depicted is the trolley terminal at Ringing Rocks Park or at Sanatoga Park. (Courtesy of the Lower Pottsgrove Historical Society.)

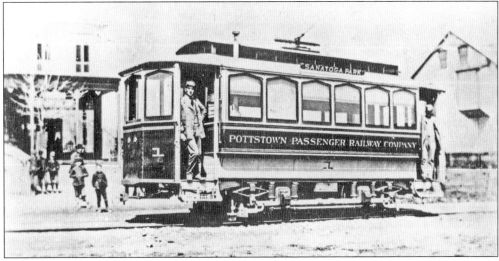

Trolley patrons expected to ride in open trolley cars in warm weather but were equally adamant that heated closed cars provide service in winter. The expense of acquiring and alternately storing two separate fleets of trolleys was not easily borne by the trolley companies. The photographer's preparation for this picture of PPR closed car 1 and its crew has attracted the curiosity of local children. (Courtesy of Andrew W. Maginnis.)

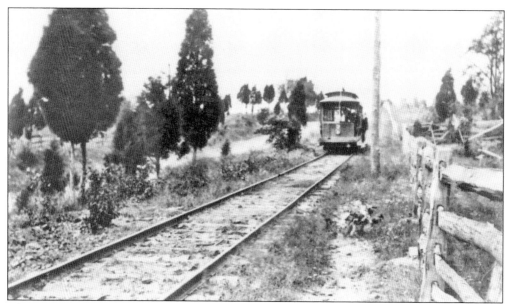

This Ringing Rocks Electric Railway open trolley's conductor is riding the running board on the outside of the car as it approaches Ringing Rocks Park. The parallel dirt road is Keim Street. North of the Pottstown borough line, much of this trolley line had its own railroad-style private right-of-way. Before the 1908 extension of the line past Ringing Rocks Park, passenger traffic was seasonal, with little to none on the outlying portion of the line in winter. (Courtesy of the Lower Pottsgrove Historical Society.)

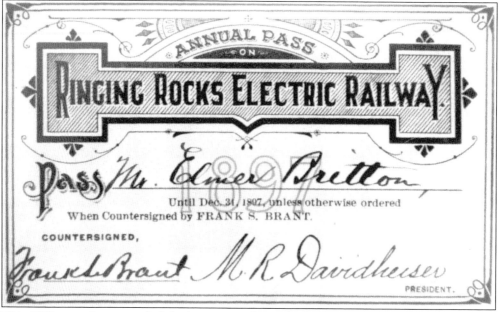

This 1897 annual pass entitled the bearer to unlimited rides on board Ringing Rocks Electric Railway trolleys. The Ringing Rocks line was independent of the Pottstown Passenger Railway Company and would be acquired in 1906 by PPR's rival, the Schuylkill Valley Traction Company. Due to a difference in track gauge, the original rails in Hanover and Charlotte Streets were ripped out and replaced. (Courtesy of the Lower Pottsgrove Historical Society.)

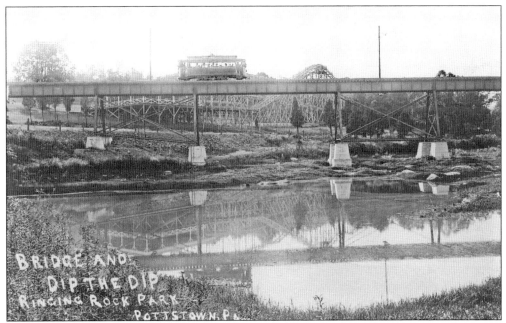

This postcard captures both the trolley trestle at Ringing Rocks Park and the wooden roller coaster that stood on the embankment above Keim Street. Until an upgraded power supply could be installed, short trolleys such as these provided the Pottstown-to-Boyertown service. It is not known precisely when the coaster was dismantled, but close inspection of 1928 aerial photography yields no trace of it. (Courtesy of Jerry Ciccarine.)

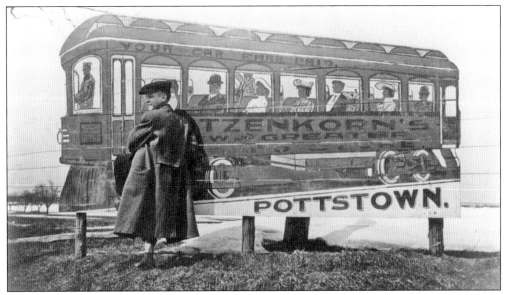

Perhaps impatient waiting for the trolley, this would-be passenger playfully attempts to climb aboard a trolley-shaped roadside billboard. Weitzenkorn's men's clothing store was founded 1864 and remains in business today on High Street in Pottstown. "Your car fare paid" by a store was analogous to having parking validated today. (Courtesy of the Pottstown Historical Society.)

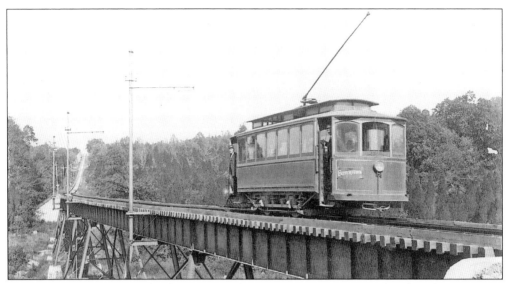

This photograph captures all of Ringing Rocks viaduct's impressive 460-foot length and 70-foot height. Beyond the bridge is the long hill that led up past Bleim Road. Schuylkill Valley Traction Company spared no expense in building the Pottstown-to-Boyertown line. It is an investment that might not have been made had it been known that the line would be abandoned less than 20 years later. (Courtesy of Stanley F. Bowman Jr.)

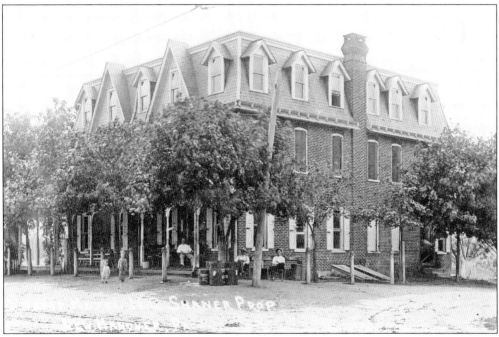

The Pottstown-to-Boyertown line served the village of Swamp in New Hanover Township. This photograph provides a glimpse of rails and overhead trolley wire on Swamp Pike at the historic Swamp Hotel, built in 1867. White-shirted people resting in the shade of the porch and west-facing windows with shutters closed attest to a hot summer day. A row of 10 concrete trolley bridge piers still marches across the meadow next to the former Swamp Hotel, today known as Our Place Restaurant. (Courtesy of the New Hanover Township Historical Society.)

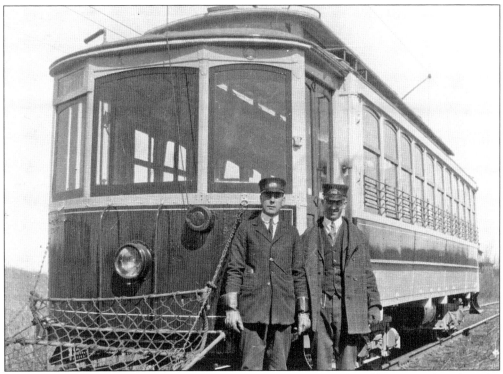

Once improved power systems were in place, larger double-truck trolleys were placed on the Pottstown-to-Boyertown line. Schuylkill Valley Traction Company motorman Syd Wallace (left) stands before a classic 1904 Brill suburban trolley along with conductor John Bryan. The location is Romigs Switch along Romig Road near Buchert Road, in what was then open countryside in New Hanover Township. The house barely visible behind the trolley still stands at 2513 Romig Road. (Courtesy of Stanley F. Bowman Jr.)

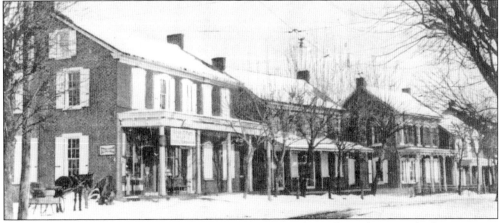

A sweeper trolley has cleared the snow from between the rails in this view looking east on Philadelphia Avenue at Wilson Avenue in Gilbertsville. Beginning in 1909, the trolley delivered mail to the Gilbertsville Post Office (the building on the left). The landmark Gilbertsville Hotel, built around 1845, stands across from the post office just beyond the right edge of the scene. With no railroad nearby, the tavern business benefited from both the patrons and the provisions brought by the trolley. (Courtesy of the Railways to Yesterday Library.)

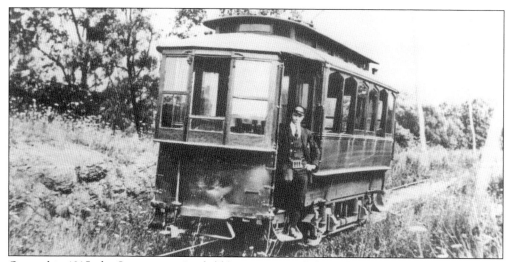

Opened in 1915, the Sanatoga-to-Linfield line was intended as a link in a chain that promoters hoped would extend through Spring City, Phoenixville, and ultimately Philadelphia. After significant sums were expended on cuts, fills, and steel bridges, the line ended abruptly at Church Road outside the small town of Linfield in Limerick Township. Never extended past this point, service was infrequent, provided by one ancient four-wheeled trolley. Here, motorman George Haas stands with what locals called the Linfield Dinky. (Courtesy of the Lower Pottsgrove Historical Society.)

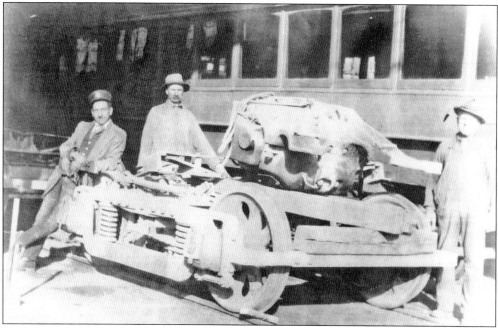

It is hoped that the trolley crewman leaning on this piece of equipment does not get his uniform greasy in this scene inside the trolley barn at 1423 High Street. Andrew W. Maginnis identifies this trolley apparatus as a Brill 27-MCB truck with one of its two Westinghouse electric motors removed. Only three Pottstown cars, delivered in 1912, rode on Brill 27-MCBs, which were designed for suburban rather than city service. Cars 103 to 105 were intended for the Pottstown-to-Phoenixville through service that was never implemented. (Courtesy of Stanley F. Bowman Jr.)

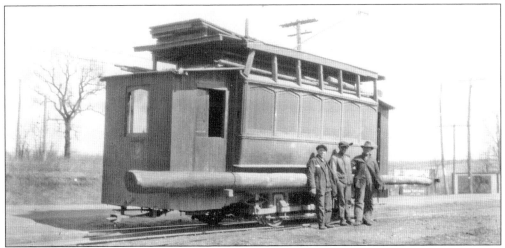

Old no. 7 was one of the original cars that inaugurated trolley service in Pottstown in the summer of 1893. After this car carried its last passenger, it had not outlived its usefulness. It was converted to a utility car, and the rough homemade vestibules no doubt inspired the nickname "the outhouse car." Howard E. Johnston's sharp October 1934 photograph captures the work car in service, with its three-man crew and a new wooden line pole suspended from the side of the car. (Courtesy of Stanley F. Bowman Jr.)

Before motor trucks were reliable and affordable and before roads were paved to run them on, the hauling of freight was an important part of the trolley companies' business. While passengers were required to change cars at Boyertown, freight trolleys rolled right through town. Here, a freight trolley pauses at Romigs Switch, a passing siding near the corner of Romig Road and Buchert Road. The small door at left allowed line poles to be slid inside, as this car was also used for trackside maintenance. (Courtesy of Andrew W. Maginnis.)

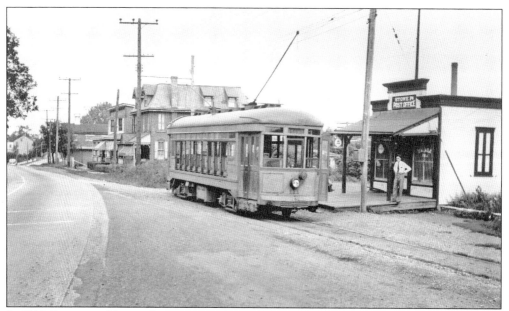

In 1923, Pottstown Transit Company was formed to operate Pottstown's High Street trolley line and the line to Linfield. At that time, the trolleys were given a fresh coat of paint featuring a brighter shade of green. The west end of the High Street line was in front of the Stowe Post Office, near the corner of High and Center Streets in West Pottsgrove Township. The post office here is long gone, but the brick house with the mansard roof still stands. (Photograph by James P. Shuman.)

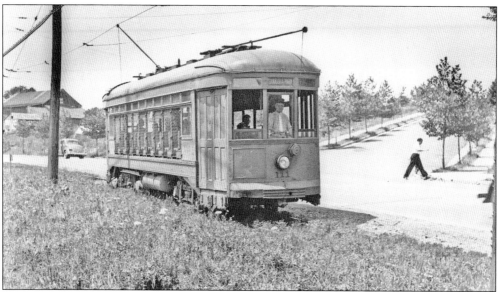

This photograph taken on High Street at Beech Street clearly shows the wire guards, similar to chain-link fence, that kept passengers inside the trolley during warmer months. To achieve an old-time open-car feel, these cars were designed so that side panels could be removed for the summer. Every autumn, the side panels were taken out of storage in the carbarn and bolted back into place. This fleet of "convertible" trolley cars carried Pottstonians from 1917 to 1936. (Photograph by Robert G. Lewis.)

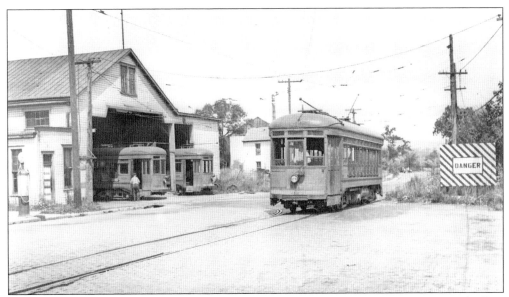

Pottstown Transit Company (PTC) trolley 111 is headed toward downtown Pottstown at the East High Street carbarn, located near the intersection with Highland Road. Because this was the borough boundary, the generous 60-foot width of High Street ended abruptly. The road continued east as a two-lane concrete highway with the trolley in the shoulder. At this point, eastbound motorists were confronted not only with a drastically narrowing roadway but also the prospect of westbound trolleys bucking traffic. (Photograph by Robert G. Lewis.)

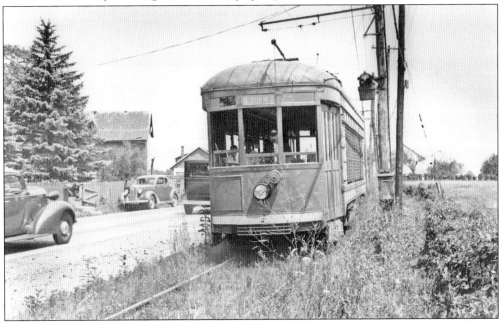

Motor vehicle traffic on East High Street is apparent in this 1936 photograph of PTC 111 westbound approaching Saylors Switch, a quarter mile west of Pleasant View Road. The automatic trolley signal above and to the right of the trolley was intended to prevent collisions on the single-track line. A 1921 head-on trolley collision had claimed three lives. This trolley will roll through downtown Pottstown, ending its run at the Stowe Post Office. (Photograph by Robert G. Lewis.)

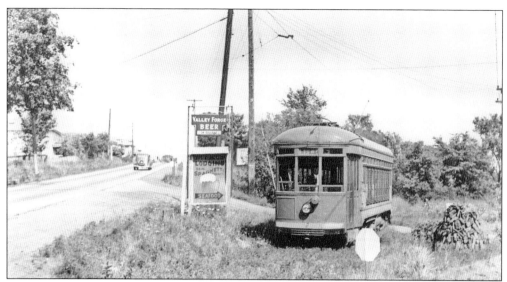

After running for five miles in and along High Street, the trolley line left the roadside at the village of Sanatoga for the final half-mile run through the woods to Sanatoga Park. Presiding over this location since before the Revolutionary War (and still today) is the old Sanatoga Inn (today known as Cutillo's). The sign in front of the inn entices passersby with Valley Forge Beer on draught, lodging, real spaghetti dinner, and seafood. (Photograph by Robert G. Lewis.)

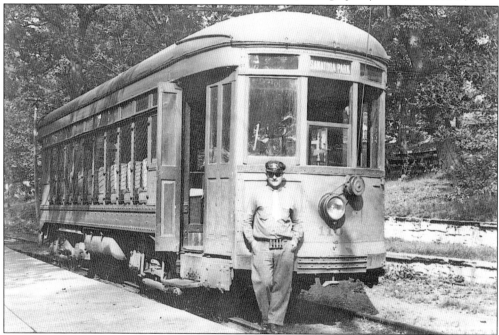

After the abandonment of the Linfield line in 1927, all High Street trolley trips ended here in Sanatoga Park. Motorman Lawrence Groff stands to have his picture taken with car 110. The last year for the trolleys was 1936, and the amusement park did not last long after that. The Alpine Dips, an enormous wooden roller coaster with nearly a mile of track, was sold in 1939. The salvaged wood is said to have found its way into the construction of nearby homes. (Photograph by Howard E. Johnston.)

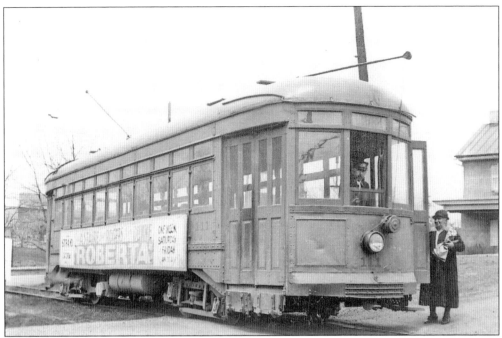

Pottstown Transit car 111 pauses at Sanatoga to pick up an eastbound passenger. The large banner on the side of the car advertises the motion picture *Roberta*, being screened at the Strand Theatre. Opened in 1925 with an exquisitely appointed interior, the Strand stood on the northwest corner of High and Charlotte Streets. Featuring Fred Astaire, Ginger Rogers, and Irene Dunne, *Roberta* was, at the time of its April 1935 release, billed as the "Queen of All Musical Romances." (Photograph by Stephen D. Maguire.)

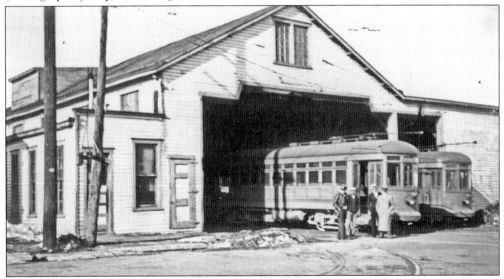

Although not in perfect focus, this photograph gives a good sense of the wood-frame East High Street carbarn during the waning years of the Pottstown trolley. The layout was unusual in that the array of steel rails and switches that provided trolleys access to the barn and to the yard alongside was embedded in concrete across both lanes of the highway. High Street through Pottstown was a major thoroughfare designated as US 422. (Courtesy of Andrew W. Maginnis.)

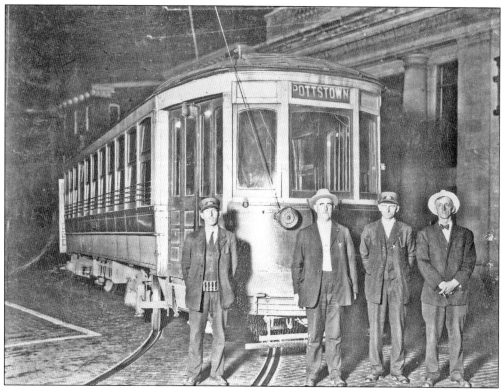

August 21, 1927, was a sad day for employees of Reading Transit & Light Company, some of whom had spent two decades keeping the trolleys running between Boyertown and Pottstown. Pictured as the last car is about to leave the corner of Philadelphia Avenue and Washington Street in Boyertown are Walter Leister, superintendent Thomas Hardaker, motorman Christian Phillips, and Earl Yerger. (Photograph by the *Berks County Democrat*, courtesy of Andrew W. Maginnis.)

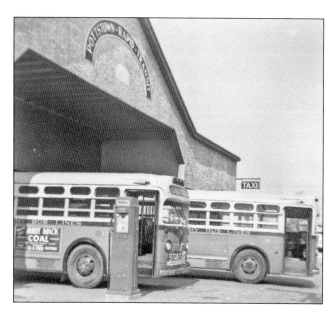

Pottstown Rapid Transit Company operated buses in Pottstown after the trolleys were retired in 1936. In 1958, Pottstown Rapid Transit Company bought out the Murphy Bus Lines, owner of the buses that ran between Boyertown and Pottstown. Pictured at the old East High Street carbarn are gasoline-powered General Motors buses Murphy had purchased secondhand from Public Service Coordinated Transport of New Jersey. Buses were removed from the carbarn in 1962. The barn was demolished in 1967. (Courtesy of Robert E. Sauer Jr.)

Two
COLLEGEVILLE, NORRISTOWN, CONSHOHOCKEN
ALONG THE RIDGE PIKE CORRIDOR

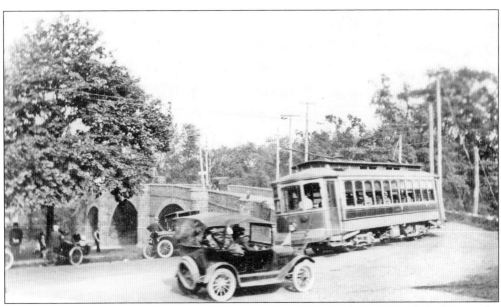

Schuylkill Valley Traction Company, known in later years as Reading Transit & Light, was the largest trolley system in Montgomery County. SVT's main Boyertown–to–Chestnut Hill route was 37 miles long; branch lines brought the total to 52 miles. This photograph, taken on Decoration Day, May 30, 1921, finds people out and about on the Perkiomen Bridge in Collegeville. The historic Perkiomen Bridge Hotel is just outside the left edge of the view. Trolleys crossed the Perkiomen Bridge from 1896 to 1933. (Photograph copyright Bruce Clark, used with permission.)

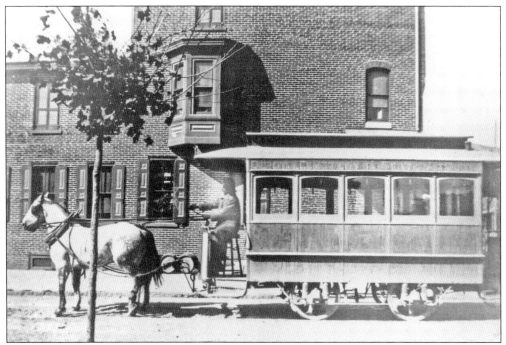

A Citizens Passenger Railway horse pulls one of a fleet of 10 passenger cars south on Stanbridge Street at Marshall Street in Norristown's West End. The line was animal-powered from its beginning in 1887 until 1893, when it was electrified. Citizens Passenger Railway's wood-frame carbarn still stands on the east side of Stanbridge Street below Sterigere Street, repurposed as an asbestos textile factory. (Courtesy of Andrew W. Maginnis.)

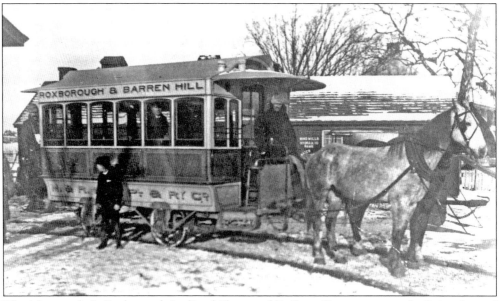

The Manayunk & Roxborough Inclined Plane and Railway Company never built its planned inclined plane, but its stable of 40 horses did pull passenger cars from Wissahickon in Philadelphia up Ridge Avenue through Roxborough to Barren Hill in Whitemarsh Township. The horsecar line opened on November 21, 1874. (Courtesy of Andrew W. Maginnis.)

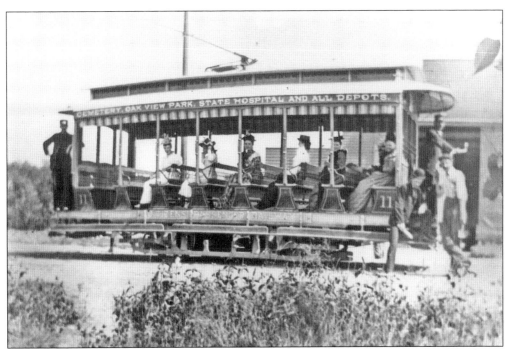

Citizens Passenger Railway car 11 was the first electric trolley to run in Norristown. The railway's Main Street and Stanbridge Street lines connected downtown Norristown with the Marshall Street commercial district, Montgomery Cemetery, Oak View Park, and Norristown State Hospital. The trolley stop at Main and Dekalb Streets was a two-block walk from the Reading and Pennsylvania Railroad stations. (Courtesy of Andrew W. Maginnis.)

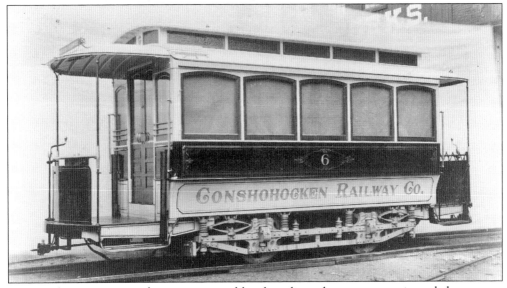

Street railway promoters often incorporated local car lines that were never intended to run on their own but were deemed more likely to win approval from local governments to place their rails in the streets. Conshohocken Railway Company car 6 was photographed at the Jackson & Sharp plant in Wilmington, Delaware, in 1895. The signboard on the roof of the car reads, "Norristown & Conshohocken." (Courtesy of Andrew W. Maginnis.)

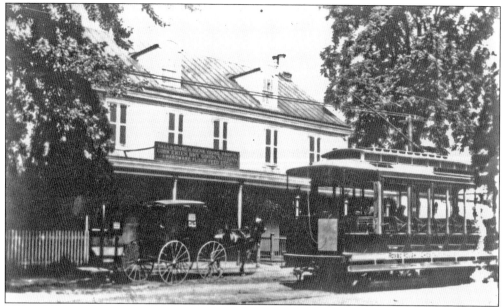

A Roxborough, Chestnut Hill & Norristown Traction Company open car pauses at the passing siding on Germantown Pike at Butler Pike in Plymouth Meeting. A quarter mile west of here, all trolley passengers needed to disembark, walk across railroad tracks, and board another trolley to continue their journeys. The railroad refused to allow trolleys to cross. This would have tragic consequences, as renowned painter Thomas Hovendon was killed by a train at the crossing along with a girl he was attempting to save. (Courtesy of Andrew W. Maginnis.)

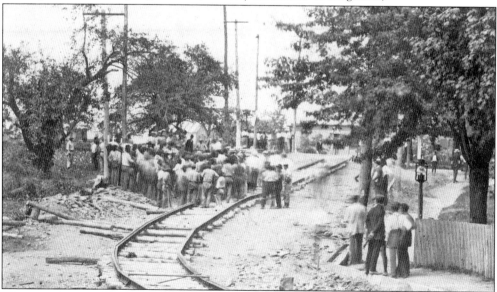

This rare photograph captures one of the so-called trolley wars that often flared when a trolley line attempted to cross a railroad. This was the era of bare-knuckles capitalism. Despite a favorable court ruling in August 1897, a crew installing Schuylkill Valley Traction Company rails in Main Street, Collegeville, was confronted by 50 men hired by the Reading Railroad (visible at the top of the hill). Shots were fired, and a least one man, struck with an axe handle, was carried away unconscious. (Courtesy of the Ursinus College Archives.)

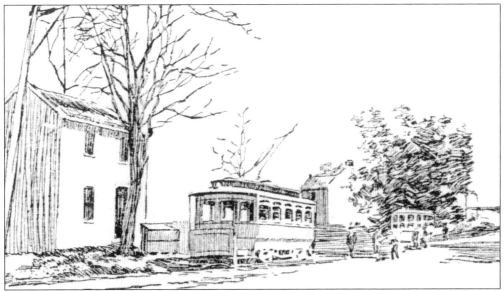

For several years, trolley riders on Ridge Pike in Plymouth Township were doubly inconvenienced, made to walk across two sets of Pennsylvania Railroad tracks a quarter mile apart. This illustration appeared in the bicycle touring series *The Roadster* on May 8, 1898. Alphonse Estoclet wrote, "The lonely 'missing link' car that you see standing near that house in ruins on the right is kept there for the sole purpose of running to and fro between the two [railroad] tracks. It's 'kind of rough' on trolley passengers in wet weather." (Author's collection.)

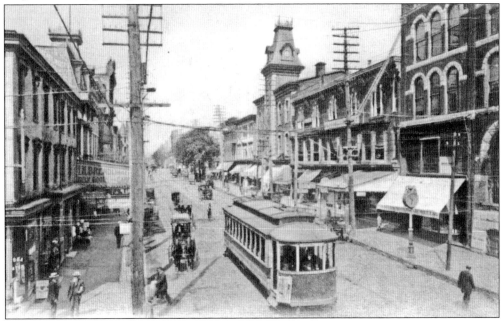

This postcard view looks west on Main Street in Norristown from the intersection with Dekalb Street. Originally painted what Harry Foesig called an "unattractive mustard colored yellow," the Schuylkill Valley Traction Company suburban car has been repainted green and cream by the time of this photograph. The double trolley track on Main Street replaced the old single track in 1903. (Courtesy of C. Pupek.)

Two photographs, taken from opposite vantage points in opposite seasons, show trolley 106 at the SVT terminus on Germantown Pike at Northwestern Avenue. This is the boundary between Montgomery County and Philadelphia, two miles from Chestnut Hill. With the exception of times of heavy traffic to White City amusement park, SVT passenger trolleys were not permitted to cross into the city. Most of the time, passengers needed to transfer to Philadelphia Rapid Transit Company shuttle cars. Between 1902 and 1908, during White City park season, SVT trolleys were allowed to continue another half mile to Hillcrest Avenue but no farther. The man on the right in the long overcoat (below) is SVT motorman Hiram Willard Poley. Brunos Restaurant occupies the mansard-roof building today. (Above, courtesy of Andrew W. Maginnis; below, courtesy of Stanley F. Bowman Jr.)

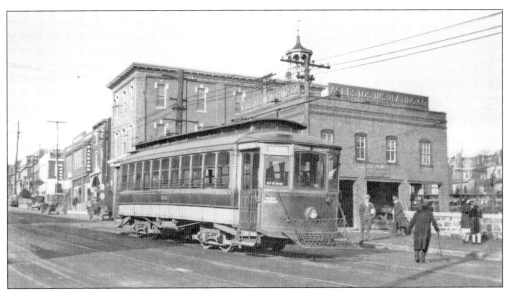

This SVT trolley, making trips between Norristown and Northwestern Avenue (signed for Chestnut Hill), changes ends on Main Street just below Astor Street in Norristown. Its route takes it out Sandy Hill Road and along Germantown Pike through Hickorytown, Plymouth Meeting, Marble Hall, and Barren Hill (today called Lafayette Hill). The trolleys are long gone, but the brick buildings and the stone bridge over Stony Creek remain today. (Photograph by William H. Watts II.)

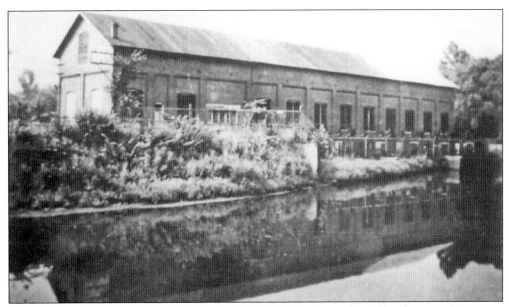

Beginning on October 28, 1914, power for Reading Transit & Light trolleys between Pottstown and Chestnut Hill was provided by the Phoenixville Water Power Company. Three hydroelectric turbines were installed at a cost of $300,000 inside this new power plant at Lock 60 of the Schuylkill Navigation, three quarters of a mile upstream from Mont Clare. As part of the project, the canal company expended a further $100,000 to rebuild the adjoining Black Rock dam. (Courtesy of the Railways to Yesterday Library.)

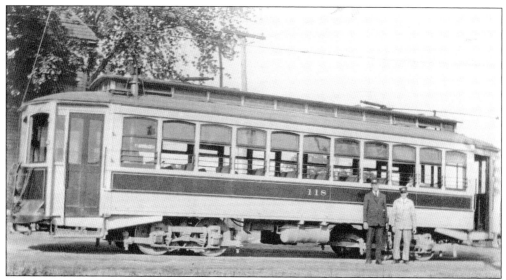

In 1910, Schuylkill Valley Traction Company was absorbed into Reading Transit Company, and in 1913, the whole became known as Reading Transit & Light. A debt of gratitude is owed RT&L motorman Syd Wallace. On many occasions, Wallace had the foresight to hand his camera to others so that he, his coworkers, the trolleys, and their environs could be recorded for posterity. Wallace (left) and conductor Austin Best stand at the *Independent* newspaper's office on Main Street at Third Avenue in Collegeville. (Courtesy of Stanley F. Bowman Jr.)

This 1932 Pennsylvania Department of Highways photograph documents tight clearances on the Ridge Pike bridge over Skippack Creek in Lower Providence Township. The view looks east towards the base of Mile Hill across the creek. In the 1890s, the Schuylkill Valley Traction Company established a low-key attraction called Skippack Park, located outside the right edge of the view seen in this photograph but gone long before this photograph was taken. Motorists must have been relieved when the trolley tracks were removed after the 1933 abandonment of trolley service. (Courtesy of Andrew W. Maginnis.)

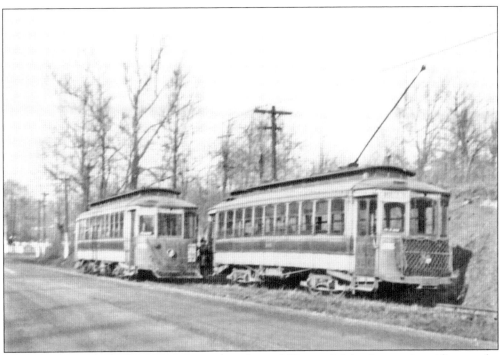

Two big deck-roof suburban cars pass on the relocated Plymouth Meeting passing siding on the north shoulder of Germantown Pike just west of Butler Pike. The original Plymouth Meeting siding had been in the middle of Germantown Pike, but it was relocated here when the highway was paved with concrete in the 1920s. The remains of a wooden trolley freight platform were visible here as late as the 1960s. (Photograph by William H. Watts II.)

In the 1890s and early 1900s, standard trolley car architecture included a raised section along the center of the roof known as a clerestory or deck roof. Beginning in the 1910s, Brill Car Company was keen on deleting that labor-intensive feature, claiming that arch-roof cars were stronger. Trolley riders were at first skeptical of the supposed improvement, citing lack of healthful light and ventilation. This 1916 photograph of RT&L car 91's interior shows how bright and attractive an arch-roof car can be. (Courtesy of Andrew W. Maginnis.)

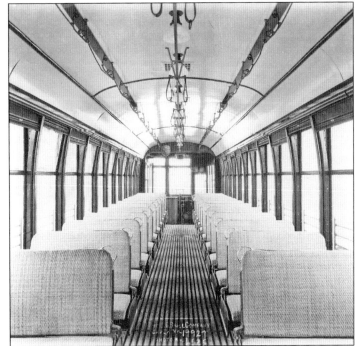

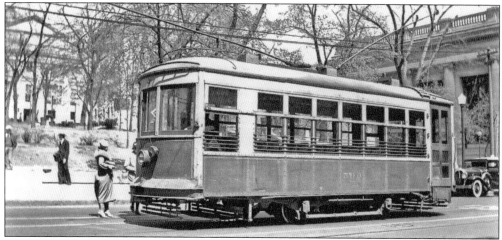

During the 1910s, trolley companies began to place in service what were termed "safety cars." Birney cars were a patented type of small safety car operated by one man without a conductor. In September 1920, RT&L introduced safety car service on its Main Street line. Here, a Birney takes on westbound passengers at Main and Swede Streets. The route was known as the "town car." It was common knowledge that due to Main Street traffic congestion, one could often make better time by walking. (Courtesy of Stanley F. Bowman Jr.)

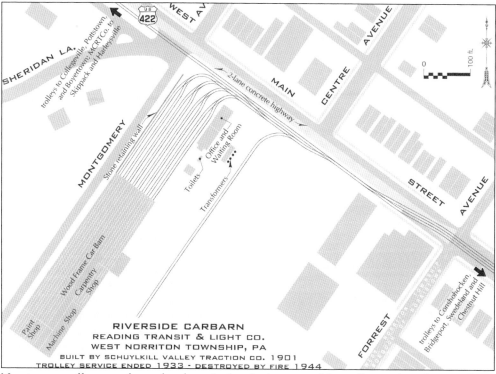

Norristown trolleys were housed and repaired at the large wood-frame Riverside carbarn on West Main Street at Montgomery Avenue in West Norriton Township. Four hundred feet in length, the carbarn had eight tracks that provided indoor storage for 60 trolleys, a paint shop, machine shop, and carpentry shop. Its construction in 1901 enabled the closure of two smaller carbarns in Norristown's West End and in Bridgeport. (Drafted by the author.)

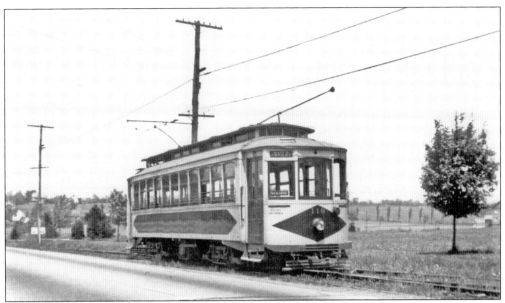

Many of the surviving photographs of Norristown-area trolleys owe their existence to William H. Watts II. As a student in the 1920s, Watts became increasingly curious about the suburban trolley lines that led out of the city beyond his Chestnut Hill neighborhood. One Saturday in May 1932, Watts aimed his camera at this eastbound trolley waiting for a westbound streetcar. The location is the Trooper switch, in the north shoulder of Ridge Pike just west of Park Avenue in Lower Providence Township. (Photograph by William H. Watts II.)

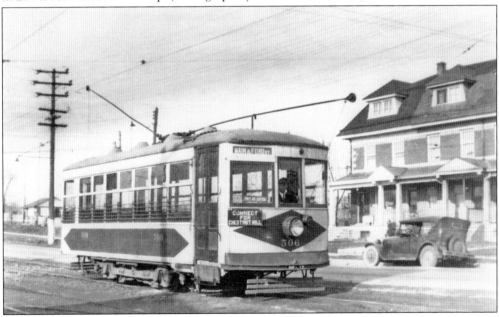

During the 1920s, RT&L Norristown Division Birney cars received fresh paint featuring large red diamonds on a cream background. With motor vehicle traffic steadily rising each year, the bold paint was no doubt intended to increase the trolleys' visibility in the eyes of motorists. This Birney car is about to head east on Main Street in front of Riverside carbarn. The three-story residences across Main Street still stand. (Photograph by William H. Watts II.)

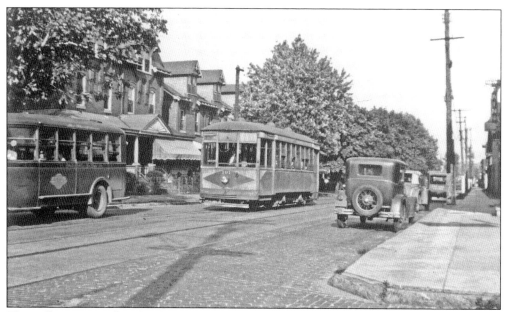

The trolleys were in their final weeks when this photograph was made on Fourth Street at Green Street in Bridgeport. More than once, the trolley line through Bridgeport to Swedeland ran as an isolated service. This occurred in 1924, when the covered bridge over the Schuylkill River was destroyed by fire, and again in the early 1930s, when construction of parallel railroad grade separation projects in Norristown severed the track connection. (Photograph by William H. Watts II.)

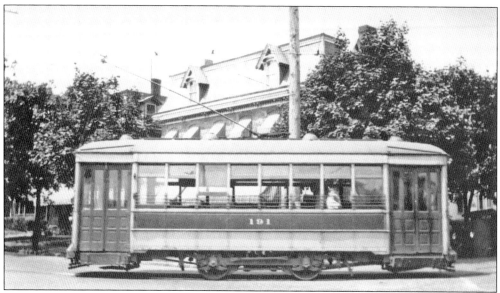

RT&L 191 squeals around the corner from Dekalb Street onto Brown Street. Trolleys in "Loop" service began and ended trips at the Reading Railroad station on Dekalb Street. Cars ran north on Dekalb Street, west on Brown Street, south on Powell and Swede Streets, and east on Airy Street (refer to the Norristown map on page 12). Between 1912 and 1923, the half mile of track on Dekalb Street beyond Brown Street to the borough line saw only limited trolley service. (Photograph by William H. Watts II.)

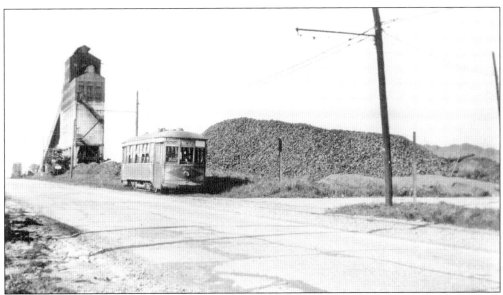

Originally intended to run from Norristown through West Conshohocken to Conshohocken, trolleys ran through Bridgeport and terminated their runs here on River Road in Swedeland. In 1894, trolley tracks were laid on the deck of the Fayette Street bridge, but those tracks were torn up by the Reading Railroad, owner of the bridge at the time. The trolley terminus at Third Street and River Road served both steel mill workers and residents of Swedeland in Upper Merion Township. The massive coke piles in the photograph above fed Alan Wood Steel blast furnaces. Today, this site is occupied by the *Philadelphia Inquirer* printing plant. (Both photographs by William H. Watts II.)

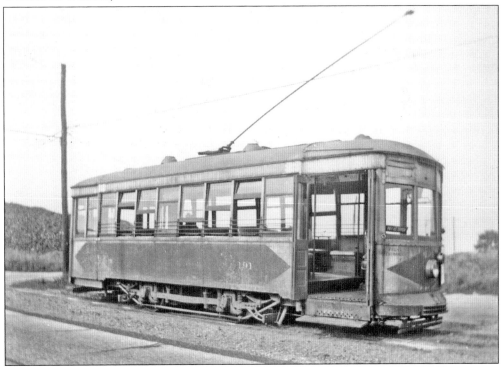

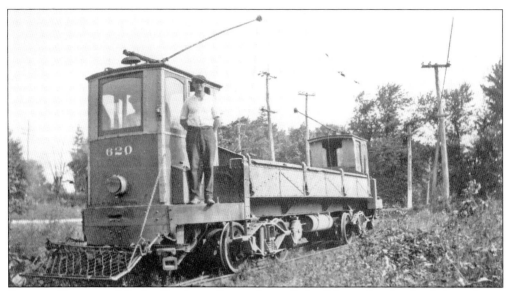

Between Trooper and Eagleville, the trolley tracks on Ridge Pike took a third-mile-long detour away from the highway. A station along this track served both Lower Providence Presbyterian Church and new houses that would be built on Second Street. RT&L work trolley 620 waits at the Eagleville switch, a passing siding parallel to West Mount Kirk Avenue. Today, Gary's World of Wellness, a health food store, occupies a commercial building erected on the right-of-way after the tracks were abandoned. (Courtesy of Andrew W. Maginnis.)

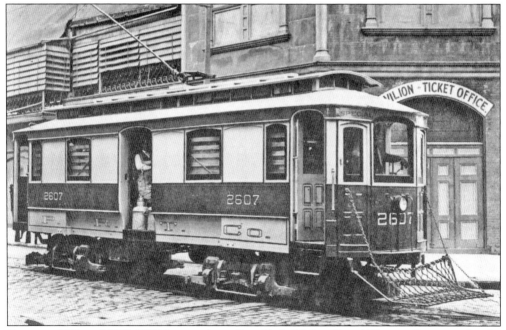

Between 1911 and 1921, RT&L agreed to allow Philadelphia Rapid Transit Company freight trolleys to operate on RT&L tracks to Norristown. The Philadelphia destination was the trolley freight depot at Front and Market Streets on the waterfront. Freight trolleys such as PRT 2607, pictured here at Baker Bowl ballpark in North Philadelphia, were rebuilt from obsolete cable cars. (Courtesy of Andrew W. Maginnis.)

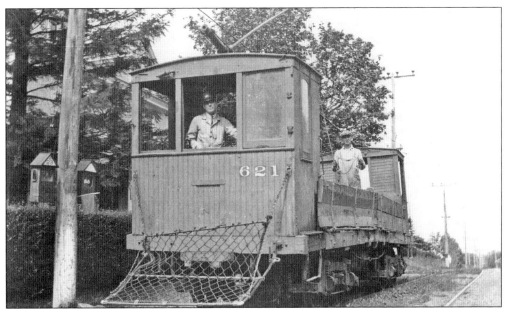

Photographs of the Ridge Pike trolley line between Trappe and Pottstown are rare. This one shows Syd Wallace at the controls of eastbound RT&L work trolley 621. The location is a passing siding on the south side of Ridge Pike 900 feet west of Township Line Road in Limerick Township. Trolley crewmen activated the signal system by inserting a brass key into the small box mounted on the trackside pole at left. (Courtesy of Andrew W. Maginnis.)

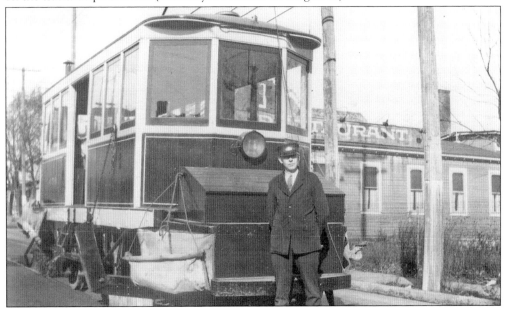

Snow sweepers were preferred to snowplows when clearing trolley tracks in streets. This was because sweepers threw snow in a more or less even blanket, whereas plows left solid snowbanks that obstructed traffic. Here, Syd Wallace stands before RT&L snow sweeper 656 on Main Street in Collegeville, between Second Avenue and Gravel Pike. The wood-frame building to the right is the Arcadia Restaurant. The precise date is not known but is likely the mid-1920s. (Courtesy of Stanley F. Bowman Jr.)

RT&L trolleys ended their Conshohocken runs on Hector Street at Walnut Street, at the borough line with Whitemarsh Township. Because significant industry lay a half mile beyond at Spring Mill, for years RT&L was urged to extend its track for the convenience of workers who rode the trolleys. This was never done. Arch-roof car 206, still in green and cream paint, is shown in front of 635 East Hector Street in Conshohocken. (Photograph by William Powelson.)

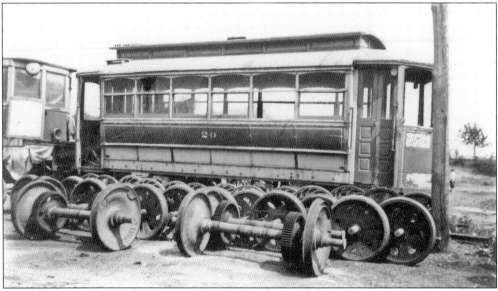

After the 1927 abandonment of the short Harmonville line, old no. 20 sat idle at Riverside carbarn. Only three-quarters of a mile in length, the dinky shuttled passengers between the Germantown Pike trolley line at Plymouth Meeting and the Ridge Avenue trolley line at Harmonville. Years of deferred track maintenance gave this trolley what retired RT&L track worker Robert Hertzler described as a "galloping gait." Sadly, in 1925, the dinky's longtime motorman Benjamin Engert, known to schoolchildren as "Big Ben" owing to his 300-pound frame, was fatally stricken at the controls of his trolley. (Courtesy of Andrew W. Maginnis.)

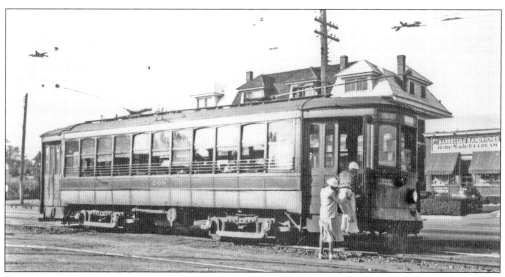

Saturday, September 9, 1933, was the last day for the old Schuylkill Valley Traction trolleys. Two women board Conshohocken-bound car 206 at the Riverside carbarn on West Main Street for a last nostalgic ride. This 1912 Brill suburban trolley rode on Brill 27-MCB trucks, giving it a top speed in the neighborhood of 40 miles per hour. (Courtesy of Andrew W. Maginnis.)

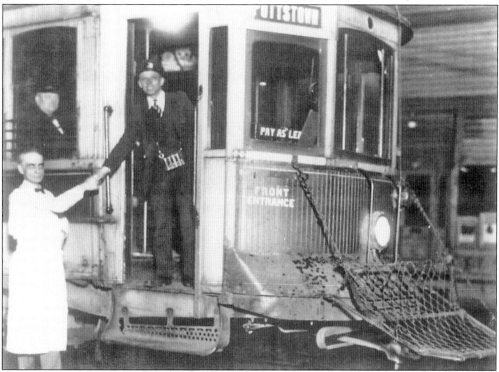

Last runs often took place at night, and the last Pottstown-to-Trappe trip was no exception. Much of this line occupied the shoulder of Ridge Pike, but more than three miles ran as private railroad-style right-of-way that bus service could not duplicate. This photograph shows the crew bidding farewell as the last car is about to depart Hanover and King Streets in Pottstown at 10:46 p.m. on January 21, 1932. (Courtesy of the Pottstown Historical Society.)

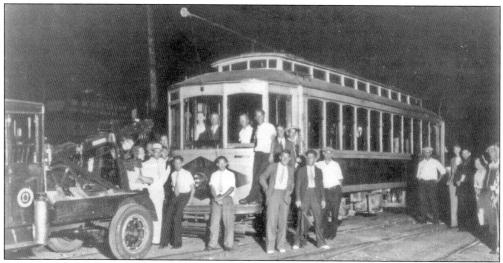

This photograph captures the SVT's final trolley trip arriving at the Riverside carbarn from Conshohocken at 2:40 a.m. on September 10, 1933. Some of the passengers had spent the evening waiting for the last run in an East Hector Street taproom. According to the *Norristown Times-Herald*, Bill Collins Sr. recalled that "it took two and a half hours to make that five-mile trip, scheduled for 28 minutes. The frolicsome passengers caused many delays. They pulled the trolley pole off the electric power line, stood in front of the car, rang up fares in the hundreds, kept the bell ringing continuously and dismayed the tired motorman throughout the voyage of good humored turmoil." (Courtesy of Andrew W. Maginnis.)

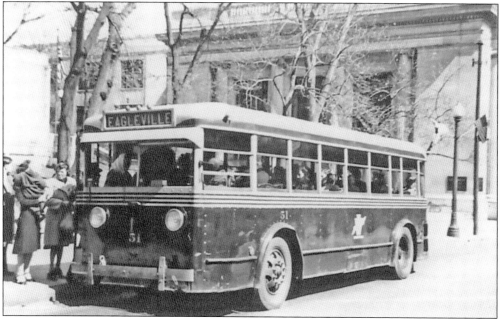

After the trolley system was abandoned, Schuylkill Valley Lines (SVL) buses served Norristown and the surrounding area from a new garage on East Main Street near Ross Street. This photograph records westbound passengers boarding SVL 51, a 1933 Yellow Truck and Coach Manufacturing Company model 711 bus with 30 seats, on Main Street at Swede Street in Norristown. (Courtesy of Robert E. Sauer Jr.)

Three

SOUDERTON, LANSDALE, NORRISTOWN
THE FAMOUS LIBERTY BELL LINE

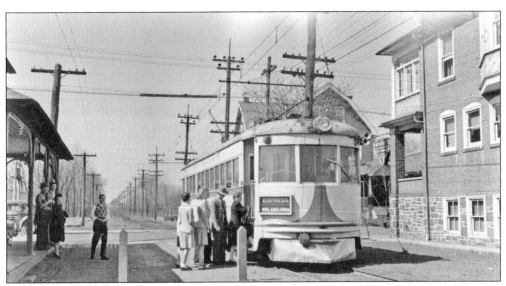

Lehigh Valley Transit Company's trolleys made a lasting impression on Montgomery County's landscape and its people from the turn of the 20th century to the autumn of 1951. During those years, LVT invested in repeated upgrades to its Liberty Bell Route, straightening trackage and running the fastest, most comfortable railcars anywhere. Passengers board bright red and cream Liberty Bell Limited car 1007 in Hatfield in April 1946. (Photograph by John F. Horan, courtesy of the Railways to Yesterday Library.)

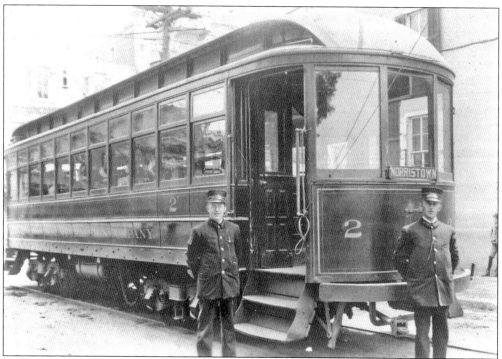

Incorporated as the Lansdale & Norristown Electric Railway Company, the first trolley to link the two towns was reorganized as the Montgomery Traction Company (MTC) in 1904. One of its large railroad-style trolleys is ready to depart MTC's Lansdale terminal in the middle of Susquehanna Avenue at Main Street. The line's zigzag route ran on portions of Green Street, South Broad Street, Garfield Avenue, West Point Pike, Morris Road, and Dekalb Pike. The carbarn (still standing) and powerhouse were in West Point. (Courtesy of the Railways to Yesterday Library.)

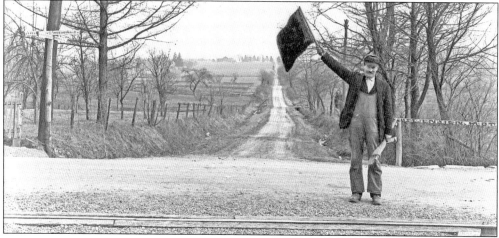

This flagman protected the trolley crossing of Township Line Road at Dekalb Pike in Washington Square. Dekalb Pike crosses from left to right, parallel to the trolley tracks. The Washington Square Inn (later known as Mr. Ron's) is back and to the left, outside the edge of the view in the photograph. The dirt lane in the distance is Township Line Road, towards the southeast. The left side of the road is Whitpain Township; on the right is East Norriton Township. (Courtesy of the Trolley Museum of Pennsylvania.)

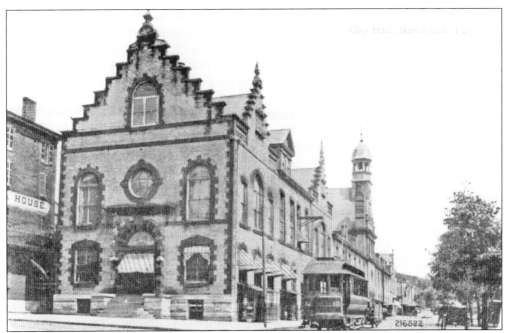

This postcard view depicts Montgomery Traction Company car 10 pulling a small trailer south on Dekalb Street at Airy Street alongside Norristown Borough Hall. In the first decade of the 20th century, trolley traffic headed north on Dekalb Street and south on parallel Powell Street in the mornings, then reversed direction in the afternoons. Although populous enough to qualify as a city in most states, Norristown was and still is classified as a borough in Pennsylvania. (Author's collection.)

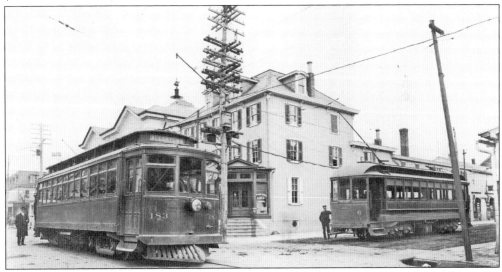

Between 1902 and 1912, the corner of Main Street and Susquehanna Avenue was Lansdale's trolley transfer point. Allentown, Chestnut Hill, and points in between could be reached by riding the Lehigh Valley Transit trolley on the left. The Montgomery Traction streetcar on the right was bound for Norristown. In 1911, LVT would buy out the Montgomery Traction line and abandon most of it but retain a portion of the old Dekalb Pike roadside track for the new high-speed line to Philadelphia. (Courtesy of the Lansdale Historical Society.)

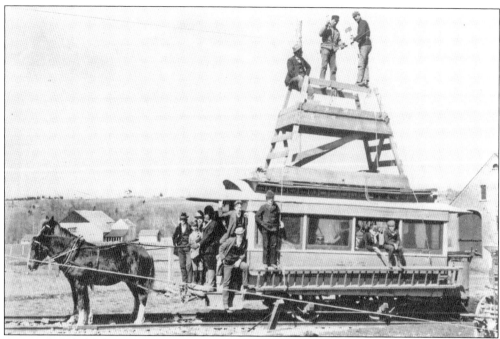

A retired Philadelphia horsecar makes a handy platform for installation of overhead trolley wire north of Lansdale in February 1900. The Inland Traction Company trolley line from Perkasie to Lansdale and North Wales opened for service later that year. Built by Allentown contractor Pascoe & Crilly, Inland Traction was intended as a key link in Lehigh Valley Transit Company's plans for an Allentown–to–Chestnut Hill line. (Courtesy of the Railways to Yesterday Library.)

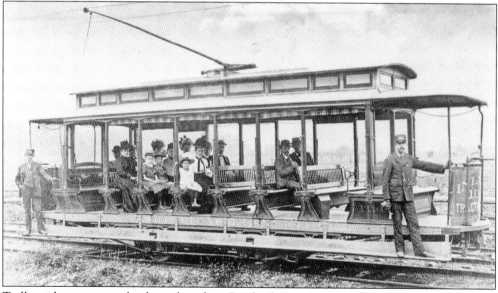

Trolley riders appear to be dressed in their Sunday best onboard an Inland Traction open car. Should the clouds overhead coalesce into a summer thunderstorm, the striped curtains visible just below the roof could be pulled down to shield the paying passengers. On an open-platform car with no windshield, the motorman was fully prepared to operate the car while exposed to the elements. (Courtesy of the Railways to Yesterday Library.)

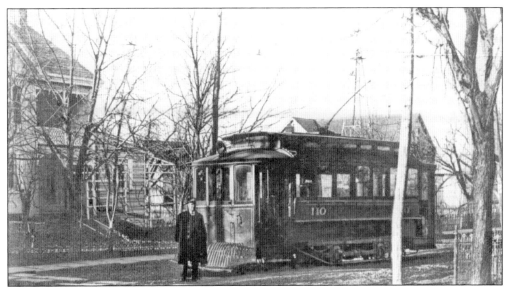

As laid out in 1899, the original route through Telford included nine sharp curves, each of which slowed the trolleys drastically. Although this route was convenient for Telford residents, in 1902, LVT built a bypass track straight from Summit Street in Souderton to Reliance Road. The old track remained in service, served by a small shuttle trolley dubbed the "Telford Tripper." In this postcard image, the Tripper's motorman stands at the end of the line, Lincoln Avenue near Main Street, in about 1915. (Courtesy of Stanley F. Bowman Jr.)

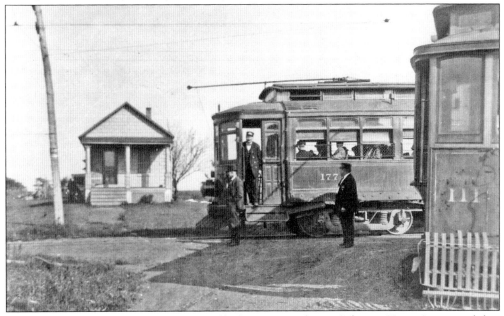

The *Goshenhoppen Region* newsletter recalls that LVT trackman Solomon Kinsey's responsibility was to walk the Telford Tripper with wrench and sledgehammer, tightening rails and banging down spikes as they worked loose. Kinsey also applied grease to the rails in tight corners to prevent wear and tear and to lessen the piercing squeal of steel wheels. The Telford Tripper was abandoned in 1925. This photograph captures trolleys meeting at Telford Junction, located on Summit Street north of Second Street in Souderton. (Courtesy of the Pennsylvania Trolley Museum.)

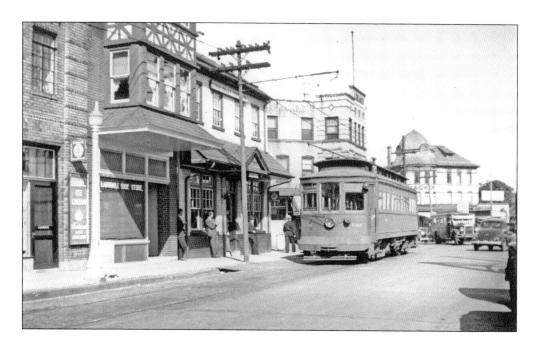

Thirty years separate these photographs of LVT trolleys in Lansdale. Both depict the big St. Louis Car Company interurban cars that arrived in 1901. In the above view, a southbound local car pauses at the LVT ticket office and waiting room on Railroad Avenue. The Beinhacker Building's dome dominates the Main Street business district. In the photograph below, taken in 1909, motorman Royden M. Clymer stands in the doorway of a well-patronized northbound trolley on Broad Street near Blaine Street. (Above, photograph by William H. Watts II; below, photograph by Howard P. Sell.)

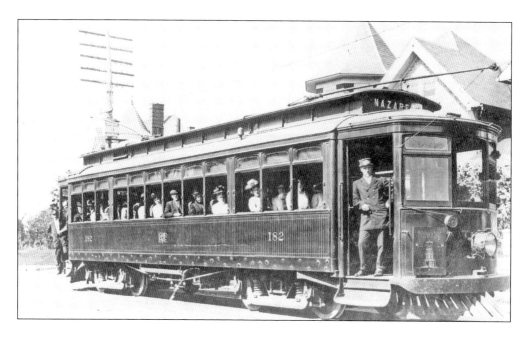

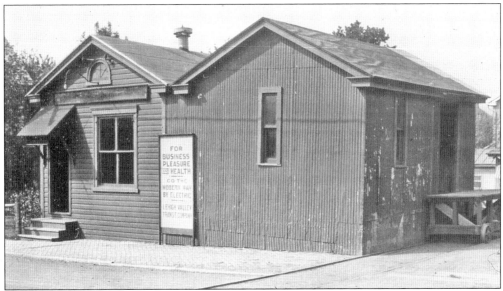

North Wales trolley passengers had the option of boarding streetcars on Main Street or walking to the waiting room in the trolley station a block away on Pennsylvania Avenue. The trolley tracks detoured away from Main Street because the Reading Railroad forbade the trolley to cross at grade on Main Street. Passengers waited in the building at left, while freight was handled in the adjoining structure at right. The sign reads, "For business, pleasure and health, go the modern way by electric." (Courtesy of the Railways to Yesterday Library.)

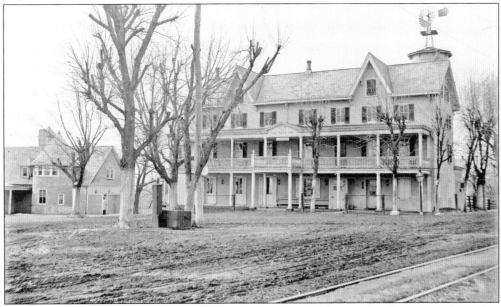

The William Penn Inn on Dekalb Pike in Lower Gwynedd Township has enjoyed a stellar reputation for over 100 years. LVT rails and overhead trolley wire along Sumneytown Pike date this photograph to sometime after 1902. Before the automobile was commonplace, convenient transit service was a boon to business. Not visible in this photograph are short-lived trolley tracks that were laid from Morris Road to this point along Dekalb Pike in 1903. Those Dekalb Pike tracks were abandoned before ever being used. (Courtesy of the Lansdale Historical Society.)

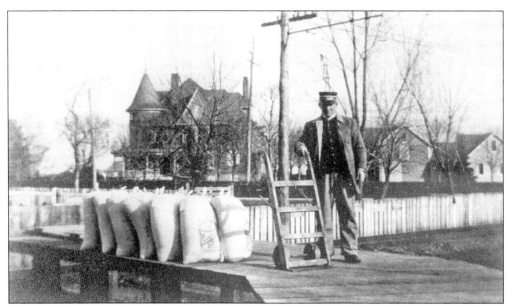

Overcoming years of staunch opposition from the steam railroads, in 1907, the state legislature passed and Governor Stuart signed the Homsher Act, giving trolley lines the right to carry freight. Freight agent William H. Fretz makes good use of a hand truck on the freight platform at Hatfield. The platform was on the east side of the station. The house in the distance still stands on Lincoln Avenue. (Courtesy of the Railways to Yesterday Library.)

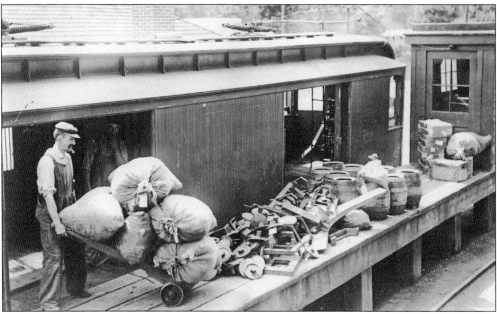

LVT trolley freight could not enter Philadelphia due to a difference in track gauge. Constructed in 1908 and enlarged in 1914, a trolley freight transfer station was established at Erdenheim in Springfield Township just outside the city limits (refer to the map on page 57). Philadelphia Rapid Transit freight trolleys served freight depots in the city, including the main terminal at Front and Market Streets. Shipments included heavy cargo such as wooden kegs and the iron castings seen here. (Courtesy of the Lansdale Historical Society.)

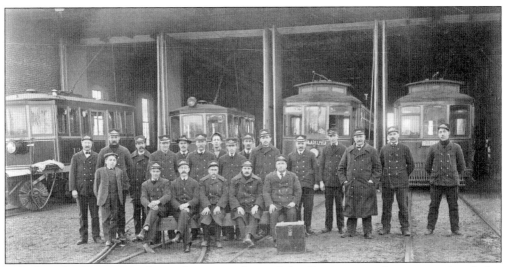

Lehigh Valley Transit employees line up in front of the Souderton carbarn on a winter's day around 1907. Located on Second Avenue near Central Avenue, its four tracks provided indoor storage and repair space for trolleys for over 50 years. After the end of trolley service, the barn was repurposed more than once, serving for many years as a supermarket. It was destroyed by fire sparked by a lightning strike on May 15, 1991. (Courtesy of the Lansdale Historical Society.)

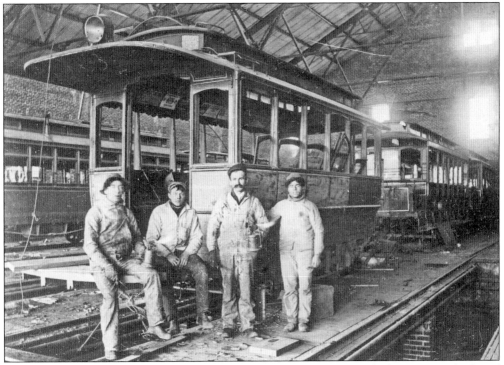

This view gives a sense of the Souderton carbarn's vast interior, with the steep pitched roof supported by steel trusses. Four workmen pause for the camera, their apparent task being the refurbishment of an old single-truck trolley. LVT's traditional Pennsylvania Dutch "waste not, want not" ethic avoided disposing of anything that could be reused with a little ingenuity and elbow grease. (Courtesy of the Pennsylvania Trolley Museum.)

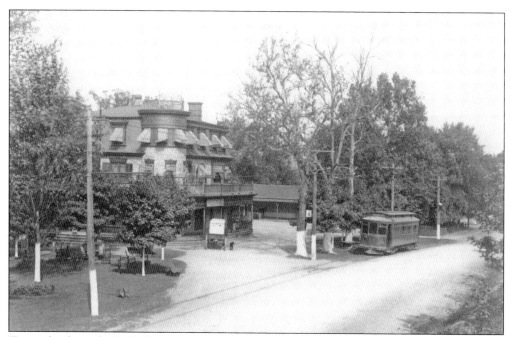

Two miles from the Erdenheim terminal, LVT trolleys passed the Fortside Inn on Bethlehem Pike at Skippack Pike in Whitemarsh Township. Advertised as "the handsomest road house in Pennsylvania" and known in later years as the Bent Elbow, the inn remains open today as MaGerks Pub and Grill. A passing track referred to as Marsh Siding was located a quarter mile farther north on Bethlehem Pike. (Courtesy of the Lansdale Historical Society.)

LVT's trolley tracks followed a mile-and-a-half detour off Bethlehem Pike in order to serve the borough of Ambler. The route included Butler Avenue, Main Street, and Bannockburn Avenue. A reverse curve on one block of Orange Street and one block of Spring Garden Street was bypassed with a more direct route in 1909. From that same year, a company photograph documents a big "St. Louie" northbound on Butler Avenue on the short block between Main Street and Spring Garden Street. (Courtesy of the Railways to Yesterday Library.)

This country view looks south on Bethlehem Pike below Church Road in Whitemarsh Township. The footpath on the left is well separated from trolley cars and road traffic. In July 1916, the Automobile Club of Philadelphia warned motorists that police on this stretch of Bethlehem Pike were enforcing a law that prohibited autos from passing stopped trolleys. When this road was paved in 1920, LVT spent a small fortune to move the trolley track to the center lane of the new concrete highway. (Courtesy of the Railways to Yesterday Library.)

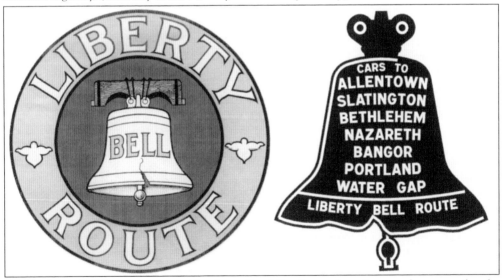

LVT's Liberty Bell logo was inspired by the trolley following, at least in part, the route taken by American patriots in 1777 as they secreted the 2,080-pound mostly copper bell to Allentown for safekeeping during the British occupation of Philadelphia. The image on the right is a re-creation of a sign displayed at LVT's Erdenheim terminal. During the years 1908 to 1912, direct trolley service was offered to Delaware Water Gap, then a significant tourist destination. (Left, courtesy of the Railways to Yesterday Library; right, drafted by the author.)

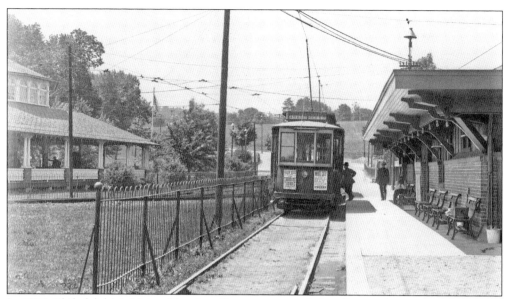

In 1898, Philadelphia's Union Traction Company extended trolley tracks a quarter mile into Montgomery County to reach a new amusement park in Erdenheim, Springfield Township, that would become known as White City. Four years later, LVT trolleys to Allentown began and ended their trips at the nearby historic Wheel Pump Inn. Both trolley systems moved their operations to a new terminal at the White City park entrance in 1907. The view in the above photograph looks south at a city trolley, its destination sign displaying Fourth and Ritner Streets in South Philadelphia, on July 6, 1910. One of White City's carousels is on the left, with the passenger terminal on the right. The view in the photograph below looks north with an LVT trolley waiting on the opposite side of the passenger terminal. The large building housed an electrical power plant and survives today as part of a lumberyard. (Both, courtesy of the Railways to Yesterday Library.)

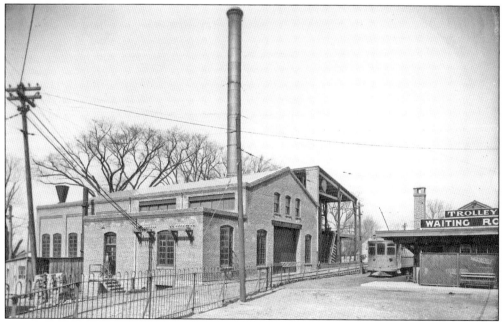

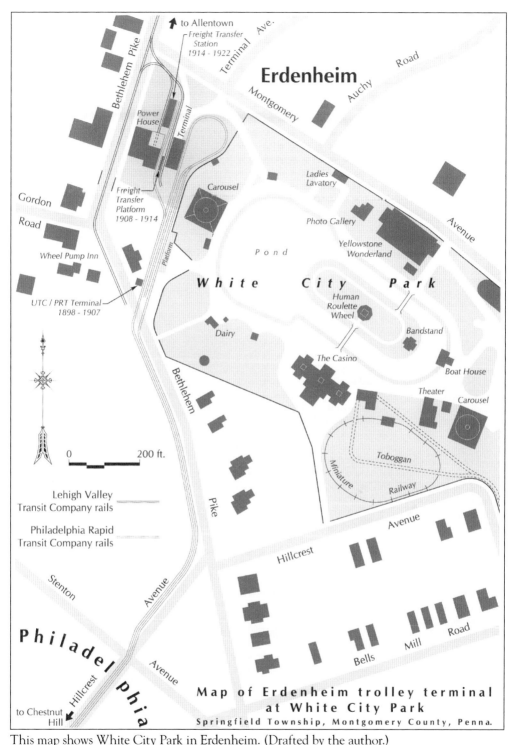

This map shows White City Park in Erdenheim. (Drafted by the author.)

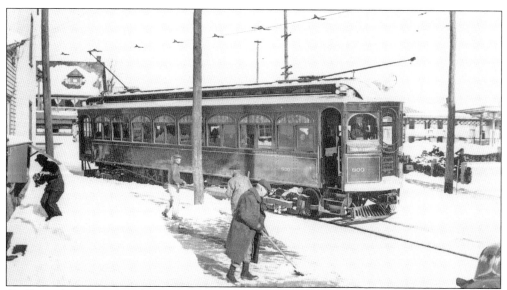

On December 12, 1912, Lehigh Valley Transit Company inaugurated high-speed service between Allentown and Philadelphia over an alignment that alternated between center-of-street tracks, side-of-the-road tracks, and new railroad-style bypasses. The new line reached the outskirts of Philadelphia at Upper Darby by way of Norristown. LVT's claim that its were the finest electric trains in the world was no idle boast, as these photographs attest. Built by high-end railcar builder Jewett Car Company, the 800 series cars weighed in at 40 tons apiece and were capable of mile-a-minute speed—no mean feat in 1912. A smoking compartment (below) was fitted with comfortable armchairs, ornately crafted ceilings, and polished brass cuspidors intended to intercept spent chewing tobacco before it reached the linoleum floor. The above photograph captures Philadelphia-bound LVT 800 turning from Main Street onto West Broad Street in Souderton as the sidewalks are being cleared of snow. (Above, photograph by Howard P. Sell; both, courtesy of the Pennsylvania Trolley Museum.)

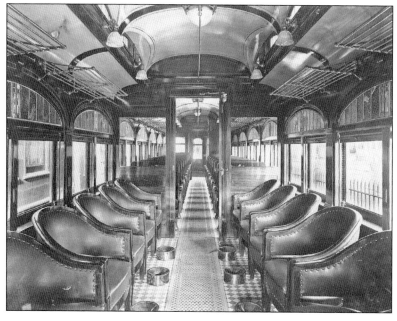

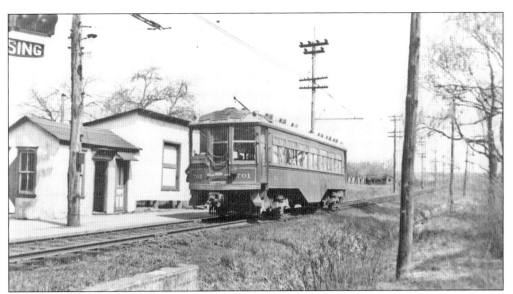

In 1931, LVT selected several 1916-vintage suburban trolleys for rebuilding into luxurious Deluxe Limiteds. Entry doors were altered, and modern electric resistance heat replaced coal stoves. The observation lounge seen below was fitted with a sofa, chairs, lamps, and tables, one of which featured an inlaid checkerboard. Control circuitry was revised to allow a 70-mile-per-hour top speed. LVT advertisements proclaimed "these crack electric interurban fliers are renowned for their fast and dependable service, their entire freedom from smoke and cinders, and their homelike comfort." The 1935 photograph above records a southbound Limited at the Center Square station in Whitpain Township, about to cross Skippack Pike. (Above, photograph by Wilbur G. Sherwood; both, courtesy of the Railways to Yesterday Library.)

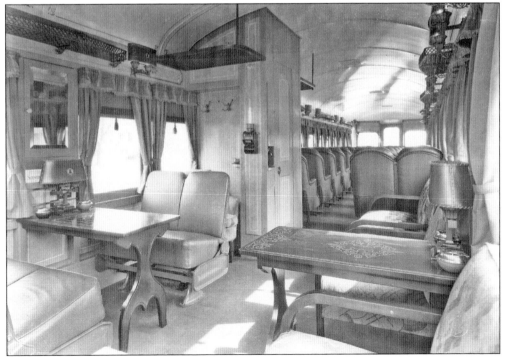

THINGS ARE COMIN' ALONG FINE !

A PROGRESS REPORT— We are happy to announce real progress in every phase of our modernization program.

Public enthusiasm is evidenced in the glowing comment from every quarter on our modernized Easton Limited and Allentown-Philadelphia Liberty-Bell lines. These handsome, comfortable, completely-rebuilt cars have given to our patrons a new era in transportation luxury and put these two lines on a par with the finest in the nation.

Pressured by steadily declining revenues, LVT's managers at Electric Bond and Share Company hired consulting engineers to determine the feasibility of continuing electric trolley service. The study's findings were a surprise to nearly everyone. The engineers recommended renovating the rail lines and purchasing modern trolleys. Because so many interurban lines had failed during the Depression, nearly new high-speed trolleys were readily available secondhand. This card issued by the company in 1939 assures customers that the promised upgrades are on the way. (Courtesy of the Railways to Yesterday Library.)

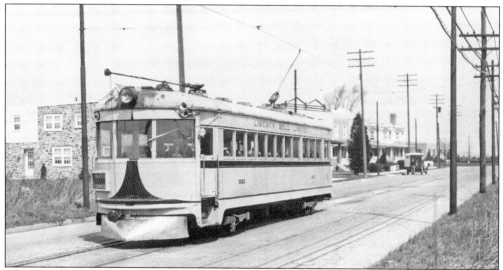

The stars of the fleet were 13 trolleys purchased from the defunct Cincinnati & Lake Erie Railroad. Built in 1930 and capable of speeds in excess of 80 miles per hour, they were referred to as "Red Devils" during their years in Ohio. A Pathe newsreel documents a publicity stunt featuring a Red Devil outpacing both a race car and an airplane. In 1939, LVT reconditioned these cars for service on the Philadelphia division. This car is southbound on Markley Street in Norristown just below Johnson Highway. (Photograph by Leslie R. Ross.)

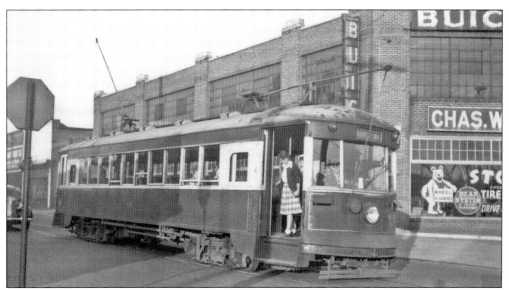

The 1939 modernization program also replaced the trolleys that provided local service. Six lightweight cars, built by Kuhlman Car Company in 1926, were purchased from the Stuebenville, East Liverpool & Beaver Valley Traction Company in Ohio. Workers at LVT's Fairview shops revised both ends with wider windshields for enhanced visibility, while lending a more modern appearance. Painted red with white trim, these cars were capable of 60 miles per hour. This southbound trolley pauses to discharge a passenger on Markley Street at Marshall Street in Norristown. (Courtesy of Andrew W. Maginnis.)

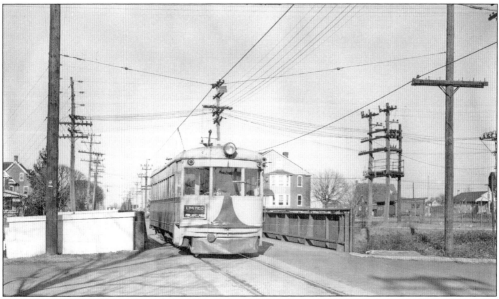

Thirteen of the "Ten Hundred Series" high-speed cars were built by the Cincinnati Car Company in 1930. That year, one car made a special trip to Philadelphia for high-speed testing on the Philadelphia & Western Railway. At the same time, in an effort to gauge LVT's interest, the car made a round-trip to Allentown over the Liberty Bell line. Years later, this photograph finds a Ten Hundred Series car in regular service southbound on Summit Avenue at Railroad Avenue in Souderton. (Photograph by David H. Cope.)

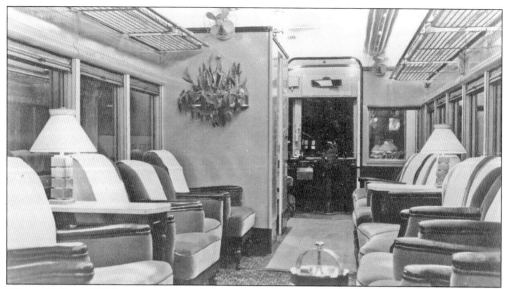

Liberty Bell car 1030 was fitted as a club car, with 24 individual upholstered chairs. Magazines bound in leather covers were placed on tables, and a bronze flower box was planted with sansaveria and philodendron. The car was cleaned and inspected between each run. This unique trolley was purchased from the Indiana Railroad in 1941 to replace one of the Cincinnati cars that had been lost to an electrical fire at King Manor. Car 1030 can be ridden today at the Seashore Trolley Museum in Maine. (Photograph by Howard P. Sell, courtesy of the Railways to Yesterday Library.)

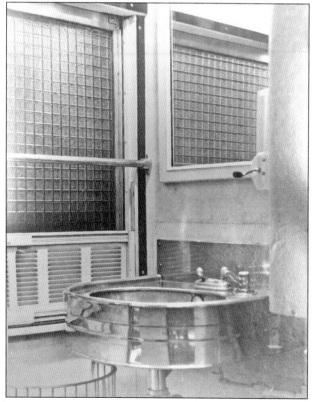

Passenger comfort was a priority for LVT. The high-speed cars provided a water cooler with paper cups and a compact lavatory. A windowpane of patterned frosted glass ensured privacy. During warmer months, the window was partially raised and a louvered steel panel fastened in place. (Courtesy of the Railways to Yesterday Library.)

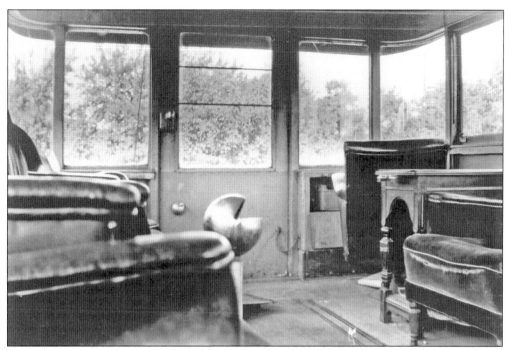

The observation end at the rear of the high-speed cars looks like an inviting, if slightly threadbare, place to relax and enjoy the ride. The rear door was added to these cars when it was realized that, in case of an emergency, there would be no way to exit the car when on the three-quarter-mile-long viaduct over the Schuylkill River. At the time, there was only one emergency walkway on the upstream side. (Courtesy of the Pennsylvania Trolley Museum.)

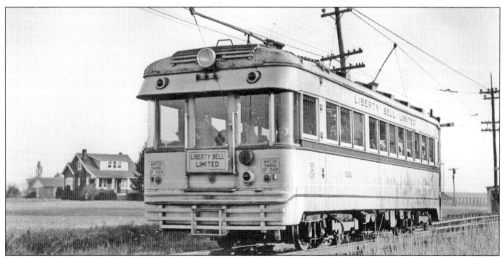

At both ends of the line, in order to turn "Ten Hundred Series" cars around, the trolleys were operated in reverse using a small set of controls concealed in a cabinet beneath the rear window. After service was cut back to Norristown in 1949, this was done on Swede Street and Airy Street also. In an unusual scene recorded on October 11, 1947, LVT 1001 runs in reverse on private right-of-way between Telford and Souderton. (Photograph by Charles A. Brown, courtesy of Edward H. Lybarger and the Pennsylvania Trolley Museum.)

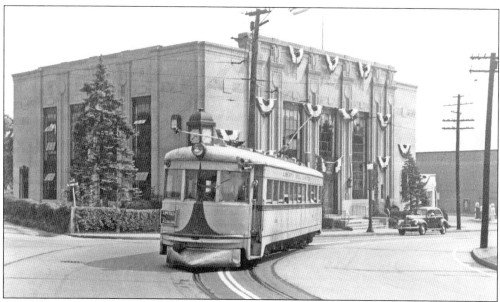

One of the most remarkable things about the Liberty Bell line was the wide variety of settings in which the trolleys ran. Running upwards of 80 miles per hour between towns when necessary, the motormen needed to rein in these thoroughbreds when mixing with street traffic in the towns along the way. Here, a northbound Ten Hundred Series car negotiates the tight turn from West Broad Street onto Main Street in Souderton. (Photograph by Charles W. Houser Sr.)

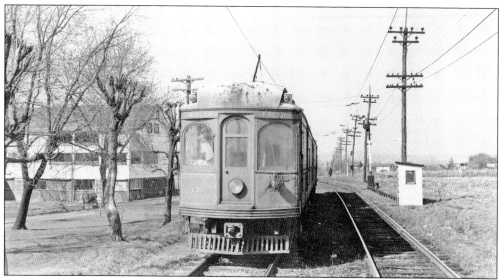

Freight trolleys were a regular sight on the Liberty Bell line right up until the end in 1951. With most of them rebuilt from the palatial heavyweight cars built in 1912, freight cars were often coupled together in two- and three-car trains. Their destination was the freight terminal next to P&W's Seventy-Second Street shop in Upper Darby, just outside Philadelphia. This two-car train is southbound at Nace Siding between Telford and Souderton in April 1946. (Photograph by John F. Horan.)

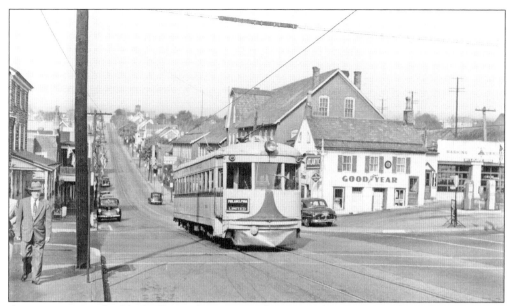

At seven percent, this block of Main Street in Souderton was the steepest grade on the Liberty Bell line. Winter weather caused tie-ups here, as motor vehicle traffic packed down snow and ice onto the rails. In this scene recorded in better weather, a southbound Ten Hundred Series car scoots up the grade. (Photograph by David H. Cope.)

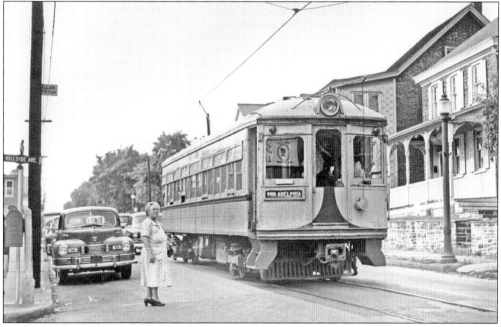

In the late 1940s and early 1950s, deferred maintenance often meant that one or more of the high-performance Ten Hundred Series cars were sidelined due to mechanical problems. At those times, older trolley cars were pressed into service. This September 1948 photograph captures LVT 710, built in 1916 and rebuilt in 1923 and again in 1931, southbound on Main Street in Souderton. The expression on the matron's face seems to question why on earth anyone would aim a camera at an old trolley. (Courtesy of the Pennsylvania Trolley Museum.)

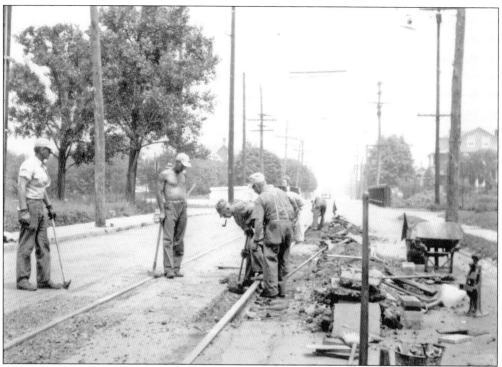

Maintaining the Liberty Bell line provided steady work for skilled crews. The rails in Summit Street in Souderton are being repaired above. Below, an overhead wire crew repairs the catenary on Broad Siding between Lansdale and North Wales. The date of the photograph is November 28, 1947, and the men are identified as R. Dunbar, C. Snyder, and S. Schoenberger. The Liberty Bell line's overhead alternated between stretches of simple trolley wire and the more complex catenary. (Above, photograph by Lester K. Wismer; below, photograph by Charles W. Houser.)

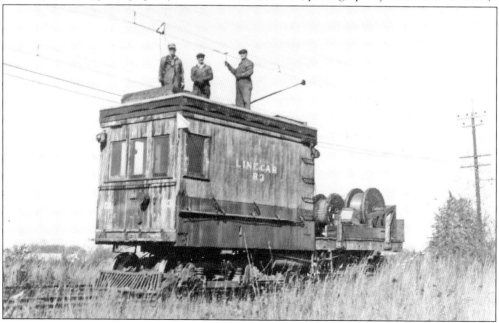

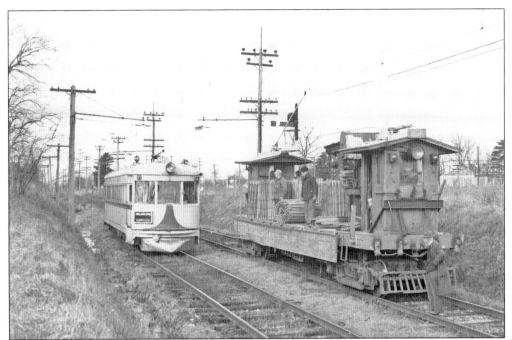

An annual rite of fall was the erection of snow fence. Large spools of red-painted lath fastened together with wire were unrolled and set up along highways and railroads subject to drifting powder during and after snowstorms. In the spring, snow fence was taken down, rolled up, and stored until the following fall. This southbound trolley is passing a work crew putting up snow fence along Angle Siding, just north of Lansdale. The man at right is maintenance-of-way superintendent William Rosenberger. (Photograph by Lester K. Wismer.)

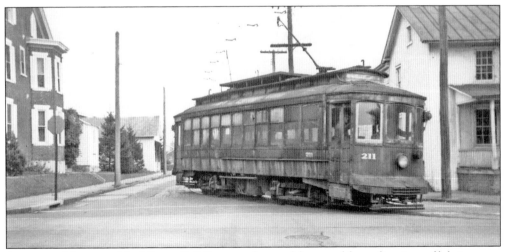

An unusual feature of the Liberty Bell line was the need for monthly applications of lubricant on the overhead trolley wire. Because high-speed operation would sometimes shatter the traditional current-collecting brass wheels atop trolley poles, LVT substituted more reliable sliding shoes. To prevent damage to the copper wire, an old trolley was equipped with an air compressor that forced light grease through a thin tube attached to a second trolley pole. The "grease car" turns from Summit Street onto Main Street in Souderton. (Photograph by Lester K. Wismer.)

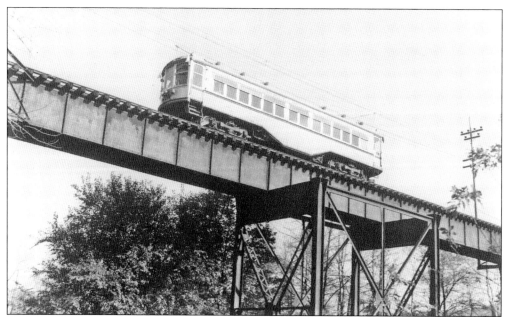

When the side-of-the-road trolley line between Souderton and Hatfield was abandoned and replaced with a straighter railroad-style line in 1912, this 270-foot-long steel bridge was constructed over Township Line Road and a tributary to Skippack Creek. Known as Gehman's Trestle, it had supporting piers wide enough to support a second track that was never built. (Photograph by Charles W. Houser Sr.)

Ex–Steubenville, Ohio, car 430 straddles the inspection pit inside the Souderton carbarn. Of the original fleet of seven cars, each named for Ohio cities, six were purchased by LVT in 1939 to provide local service over the Liberty Bell line. In Ohio, car 430 had been known as *Beaver*. Another red ex-Steubenville car is visible at right, with an older 700-series car wearing Liberty Bell Limited cream-and-red paint between them. (Photograph by David H. Cope.)

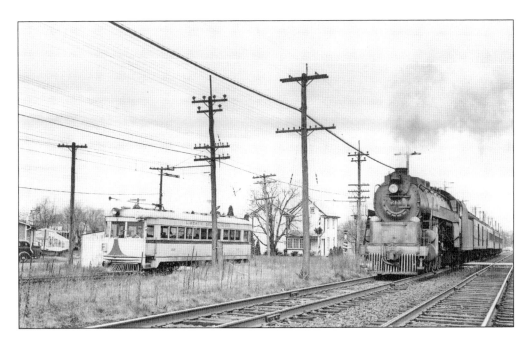

With so many miles of parallel track, dedicated trolley fan and skilled photographer Lester K. Wismer had long wanted to capture an LVT trolley racing side by side with a Reading passenger train. With that goal in mind, Wismer often staked out this location south of Vine Street in Hatfield Borough. His patience and persistence were rewarded more than once. Years later, Hatfield would use this photograph as the basis for a new borough seal. Today, a half mile of former trolley line in the borough has been repurposed as the Liberty Bell Trail. With the vacant track bay surviving as an earthen access road in a utility corridor, further extension of the rail trail is anticipated. (Above, photograph by Lester K. Wismer; below, photograph by the author.)

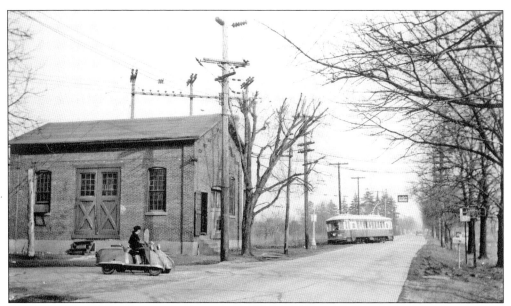

The Lansdale substation was on the corner of Squirrel Lane and West Main Street. Couter Siding, a passing track, was located along Squirrel Lane, outside the left edge of the view in this February 1950 photograph. The superelevated (sometimes referred to as "banked") track is made evident by the aggressive lean of this northbound local car. In later years, when a transformer here was disabled by a lightning strike, it was not replaced. The photographer's brother waits on a Salisbury scooter at left. (Photograph by Lester K. Wismer.)

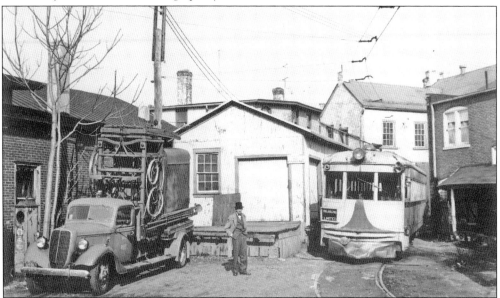

By 1950, it was common knowledge that the Liberty Bell line would not last much longer, and in fact it would be gone within a year of this November 1950 photograph. Trolley cars assigned to local Norristown-to-Lansdale service were stored between runs on this spur track that accessed the Lansdale freight station on Courtland Street. On this day, a "Ten Hundred Series" car, probably disabled, is parked on that track. The photographer's father, Henry L. Wismer, stands by a 1937 Ford wire maintenance truck. (Photograph by Lester K. Wismer.)

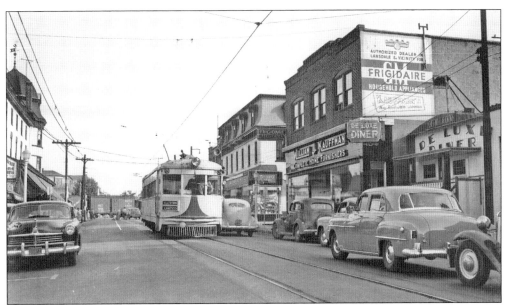

Because photographer Edward S. Miller recorded such exact notes, this photograph of northbound Liberty Bell Limited 1002 on Main Street at Green Street in Lansdale can be precisely timed at 3:22 on Tuesday afternoon, October 3, 1950. A freight train occupies the Reading Railroad grade crossing in the background. Determined to avoid troublesome railroad crossings when the trolley line was laid out in 1899, the trolley track makes a right turn just before the railroad. (Photograph by Edward S. Miller.)

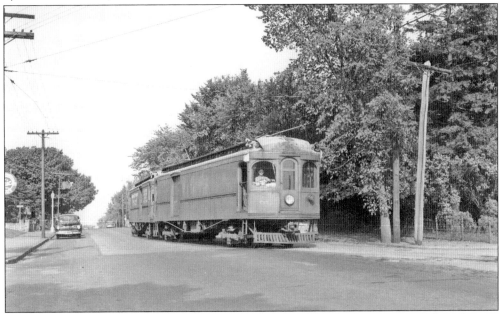

A two-car trolley freight train leaves South Broad Street at Blaine Street in Lansdale and enters a five-mile-long stretch of private railroad-style right-of-way. The freight's high-speed run will be slowed briefly where the track joins the shoulder of Dekalb Pike south of Center Square. Although the rails were torn out more than 60 years ago, as this is written, cracks in Broad Street's asphalt overlay reveal this curve's precise geometry. (Photograph by Edward S. Miller.)

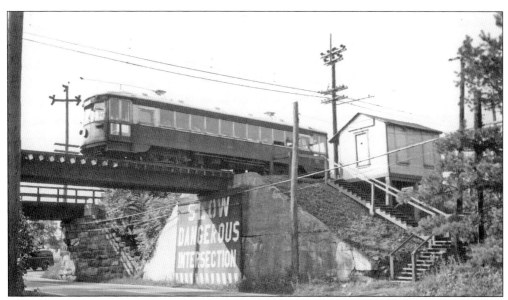

The Inland Traction Company's original line squeezed beneath a narrow bridge under the Reading Railroad Stony Creek branch. That meandering route was abandoned when the high-speed line was built in 1912 and the trolley line was placed on this bridge over Sumneytown Pike. Originally known as Kneedlers, this village was called Wales Junction because trolleys on the new line (to Upper Darby) and the old line (to Chestnut Hill) diverged here. The original trolley line to Chestnut Hill was replaced with buses in 1926. (Photograph by E. Everett Edwards.)

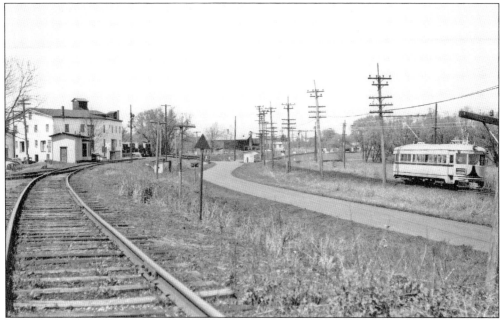

The photographer is standing on the Reading Railroad Stony Creek branch with his camera pointed north toward the grade crossings of West Point Pike in Upper Gwynedd Township. A southbound Liberty Bell Limited car is rapidly exiting the frame to the right. The road between the tracks is the old alignment of Moyer Boulevard. The large white building is Kriebel's Mill. (Photograph by Lester K. Wismer.)

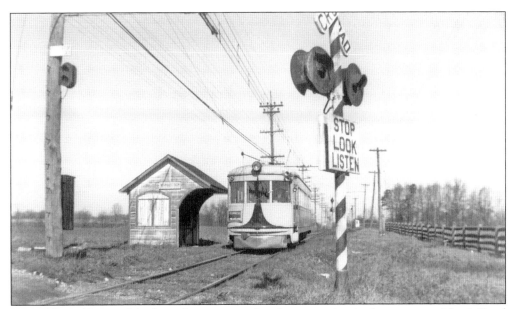

A southbound Limited, looking sharp in its red-and-cream paint, is about to cross Morris Road at the Normandy Farm station in Whitpain Township. Allentown trolley motorman Mervin E. Borgnis described riding a high-speed Liberty Bell car as "a magnificent, powerful appealing ride. It was the rocking, rolling, passenger swaying, joyous abandon of interurban railroading." More of Borgnis's reminiscences can be found in William J. McKelvey Jr.'s 1989 book *Lehigh Valley Transit Company's Liberty Bell Route, A Photographic History*. (Photograph by Richard S. Short.)

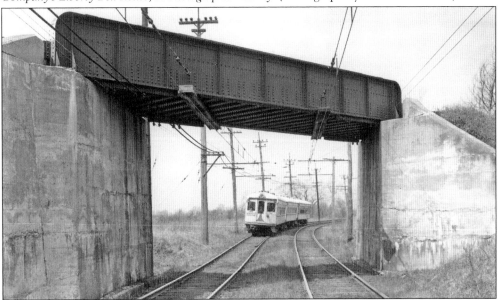

Midway between Lansdale and Wales Junction (Sumneytown Pike), the high-speed line ducked under the Reading Railroad's Stony Creek branch. This crossing was not fought over, because by this time, at least some of the railroads resigned themselves to the fact that the trolleys could serve as feeders to their lines rather than simply as competitors siphoning away business. This mile-and-a-half-long double-track section, known as Broad Siding, was the longest stretch of double track on the entire Liberty Bell line. (Photograph by David H. Cope.)

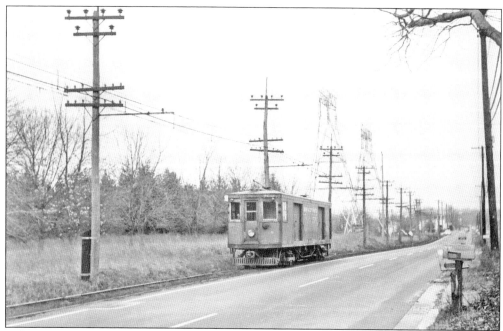

Following the side-of-the-road alignment built by predecessor Montgomery Traction Company in 1902, an LVT freight trolley is southbound in the shoulder of Dekalb Pike, south of Center Square in Whitpain Township in November 1949. The mailboxes on the right are for houses that line a private road known as Michaels Lane. The location of the future Dekalb Pike bridge over the Pennsylvania Turnpike Northeast Extension is behind this vantage point. (Courtesy of Andrew W. Maginnis.)

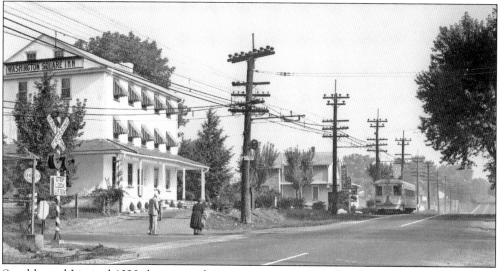

Southbound Limited 1030 slows to pick up passengers on Dekalb Pike approaching Township Line Road in Whitpain Township on October 3, 1950. LVT's brick substation, just beyond the left edge of the view in the photograph, is still standing today. The Washington Square Inn is not so fortunate. Known in later years as Mr. Ron's Publick House, the whitewashed three-story roadhouse was a landmark presence here for 200 years before being demolished in 1998 so a chain drugstore could be built. (Photograph by Edward S. Miller.)

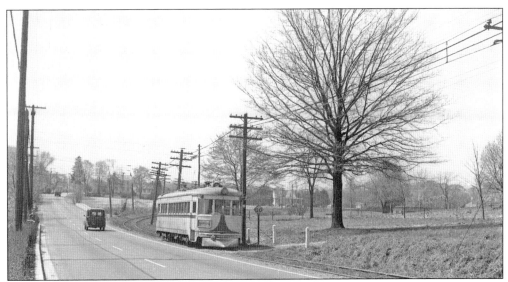

These two photographs were taken at either end of the Dekalb Pike side-of-the-road track that remained an active rail line until September 1951. Imagine out-of-town motorists' surprise when confronted with a northbound trolley coming up the southbound shoulder, especially at night. The above photograph shows a northbound Limited that has just crossed Matthias Meadow, today a strip mall in East Norriton Township. Germantown Pike crosses at the top of the hill in the distance. A fast-food restaurant now occupies the spot just behind and to the right of the trolley. The photograph below captures a northbound Limited curving away from Dekalb Pike at Cherry Road in Whitpain Township. Between 1902 and 1925, LVT moved long segments of its operation away from roadsides and onto private rights-of-way. This mile-and-a-half stretch of track along US 202 was never altered. (Above, photograph by Lester K. Wismer; below, photograph by David H. Cope.)

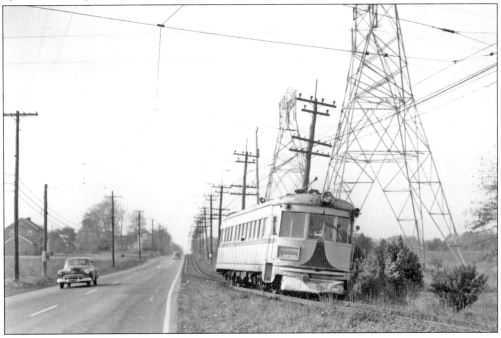

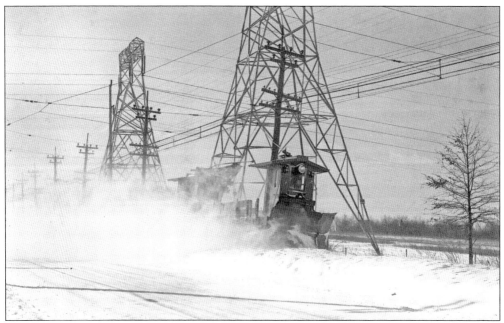

LVT trolley plow 551 clears the track northbound along Dekalb Pike at Cherry Road in Whitpain Township. The design of the steel "nose plow" cut through deep snow, pushing it to both sides of the track. A stiff northwest wind appears to be blowing the lion's share onto the highway (US 202). Montgomery County was directly in the crosshairs of this February 1947 storm, with 10 inches reported in Philadelphia and 12 in Allentown. (Photograph by Charles A. Brown.)

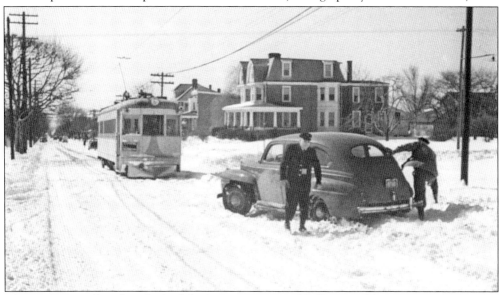

This LVT Limited car has climbed the long snow-covered hill on Markley Street in Norristown only to be blocked by an automobile stuck on the tracks. The cross streets are Brown Street on the left and Coolidge Boulevard on the right. The trolley motorman has left his post and appears to be ready to lend a hand pushing. It is hoped that when the photographer has his photograph and joins the effort, the blocking auto can be moved off the tracks. (Photograph by Charles A. Brown.)

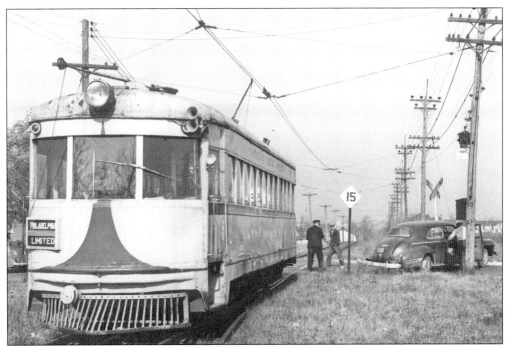

As motor vehicle traffic increased, so did collisions with trolleys. Although the trolleys were equipped with blaring roof-mounted twin Strombos air horns, motorists sometimes underestimated an oncoming trolley's speed. Road crossings were protected with signs, clanging bells, and flashing lights, but not by crossing gates. Here, a southbound Limited has struck a 1941 Buick and tossed it against a pole at School Lane between Souderton and Telford. (Photograph by Lester K. Wismer.)

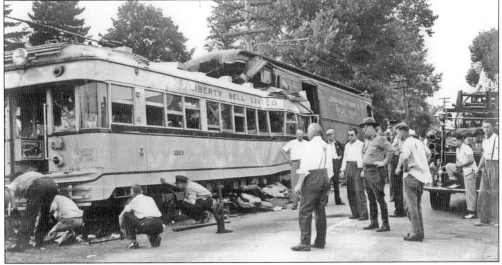

Exhausted rescuers regard the grim scene on July 8, 1942, along US 202 in East Norriton Township where a lightweight Liberty Bell Limited car has collided head-on with a heavy freight trolley during afternoon rush hour. Eleven passengers and the motorman were killed. The crash was attributed to human error. Although the Liberty Bell line would run for another nine years, many potential riders feared to patronize the service after this tragedy. (Courtesy of the Pennsylvania Trolley Museum.)

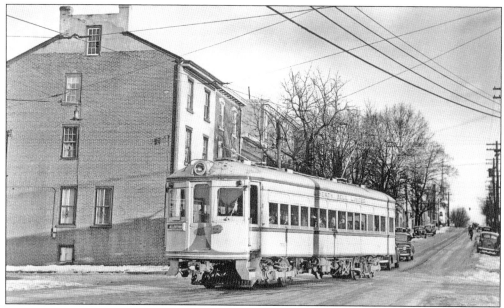

The late afternoon sun illuminates LVT 702 rolling down Airy Street, crossing Barbados Street in Norristown. At this point, the trolley rails jogged slightly to run tight against the stone retaining wall that supported the east approach of the old Airy Street bridge. After the switch for Rink Siding, the track turned north and continued up Markley Street. The date is December 28, 1947. This print is one of many in this book that highlight the superb darkroom skills of Dr. Richard L. Allman. (Photograph by Charles A. Brown.)

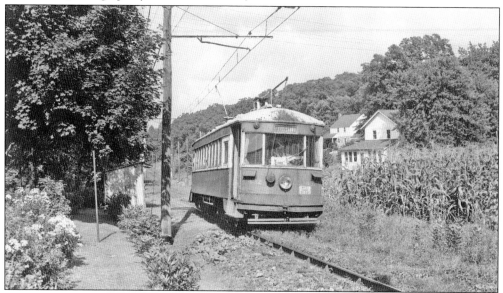

This photograph of LVT 432 southbound at Hartranft Boulevard in East Norriton Township captures the rural feel of Montgomery County, even at a location just three blocks from the Norristown borough line. The trolley right-of-way is angling toward Swede Road. The double track of Brush Siding is visible in the distance. LVT did not apply herbicide to its trolley rights-of-way. The annual carpet of verdant green was mown only by frequent contact with the undersides of passing trolleys. (Photograph by Lester K. Wismer.)

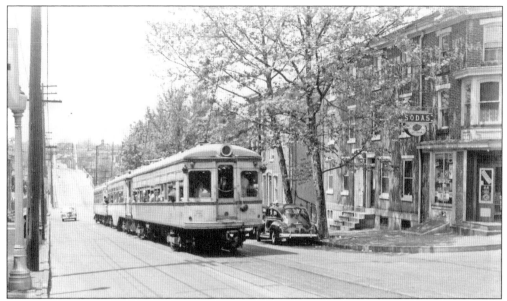

In later years, the Liberty Bell line was a magnet for trolley aficionados. Individuals and groups chartered trolleys for excursions over what was still an extensive rail network. Three-car trains of passenger cars were not used in everyday service, but LVT would couple three passenger trolleys together if paid to do so. Here, a three-car train of happy fans, many of them leaning out open windows, rolls down Airy Street at Norris Street in Norristown. (Photograph by Stephen D. Maguire.)

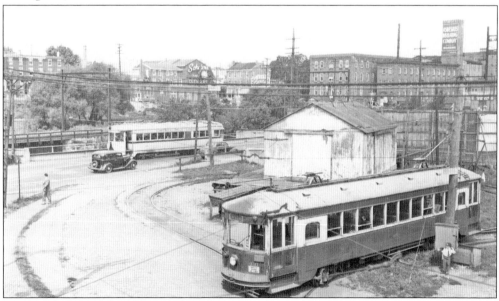

Chartered LVT 431 has taken to the siding at Rink, on the corner of Airy Street and Markley Street, to allow a regularly scheduled Limited to pass. Norristown's mills employed thousands of workers, many of whom commuted on LVT trolleys. One enterprise, Tyson Shirt Company, was renowned for its premium-quality products. Some scheduled LVT trips were informally referred to as "Shirt Factory Specials." This September 11, 1949, scene was recorded on 200 ASA Ansco Plenachrome black-and-white film. (Photograph by Richard H. Young.)

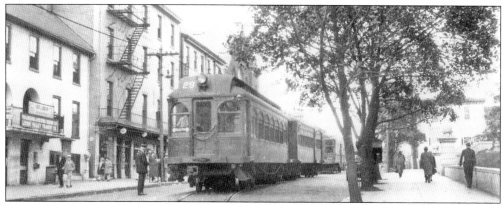

Between 1912 and 1931, all Philadelphia & Western Railway (P&W) trips to Norristown ended in the middle of Swede Street at the Montgomery County Courthouse steps. The Rambo House hotel and tavern (left) provided space for the trolley ticket office. P&W cars were equipped with overhead trolley poles, which were raised for the short half-block run down the ramp from the viaduct to the layover point. This mid-1920s photograph records two P&W cars and an LVT car stopped further up the hill. (Photograph by Frederick E. Barber.)

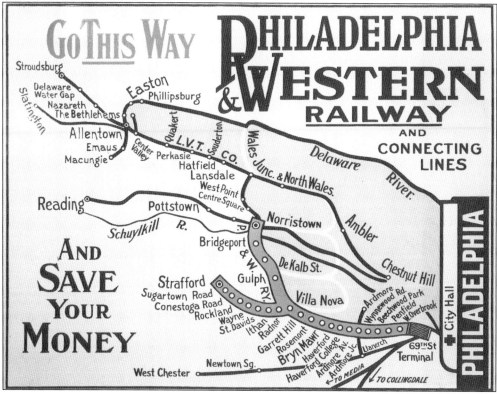

A healthy dose of artistic license was employed in the design of this stylized map. Enameled metal signs emblazoned with this map were displayed at key P&W stations. While totally omitting the network of steam railroads, these signs do portray the extent of the electric trolley system that radiated northwest from Philadelphia. The LVT lines centered on Allentown, Reading Transit & Light lines through Pottstown and Norristown, and Red Arrow lines converging at Upper Darby are represented. (Photograph by Henry Schmidt, courtesy of David W. Biles.)

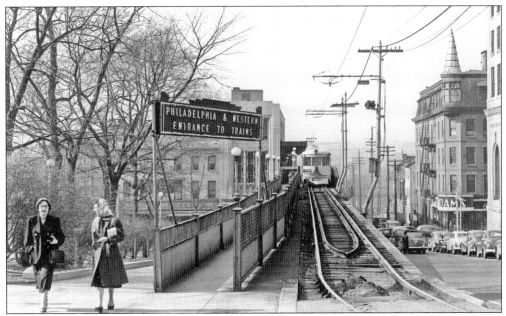

This walkway provided access from Penn Street to the second-story joint P&W-LVT station on the southeast corner of Main Street and Swede Street in Norristown. After the station opened in November 1931, P&W cars no longer descended the ramp to the old Rambo House terminal. The new station's high platforms meant that P&W's new Bullet cars did not need overhead trolley poles or steps for street-level boarding. LVT trolleys such as the Limited shown here continued to use the ramp. (Photograph by David H. Cope.)

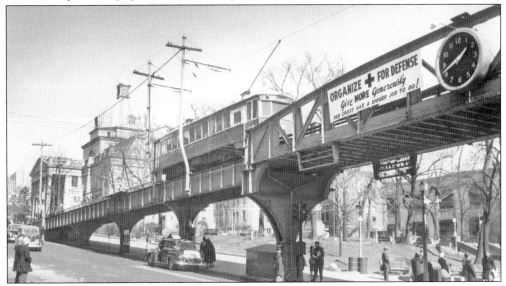

This vantage point gives a good view looking north from Main Street along the trolley ramp that led from the viaduct down to street level. LVT local cars such as this one began and ended their Norristown runs at the second-story station just outside the right edge of the scene. Beginning in 1949, Limited trolleys ended their runs at this point also, forcing Philadelphia-bound riders to transfer to P&W cars. The date of this photograph is Saturday, March 10, 1951. (Photograph by E. Everett Edwards, courtesy of the Railways to Yesterday Library.)

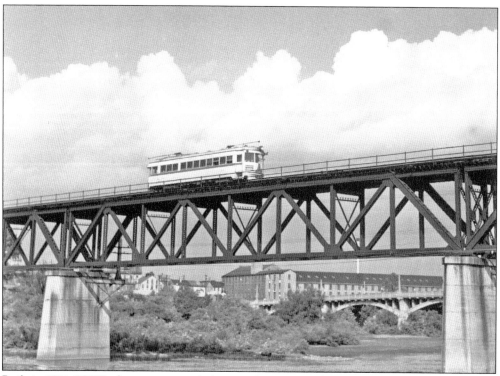

Built in 1911, P&W's three-quarter-mile-long viaduct spanned not just the Schuylkill River but also borough streets in Norristown and Bridgeport, several railroads, and a canal. LVT trolleys equipped with third-rail shoes used the bridge and 13 miles of P&W grade-separated railway to reach Upper Darby. This dramatic c. 1948 photograph captures a Liberty Bell Limited car atop the viaduct's steel trusswork. The viaduct remains in service today, carrying Norristown High Speed Line rapid transit cars. (Photograph by David H. Cope, courtesy of the Central Electric Railfans Association.)

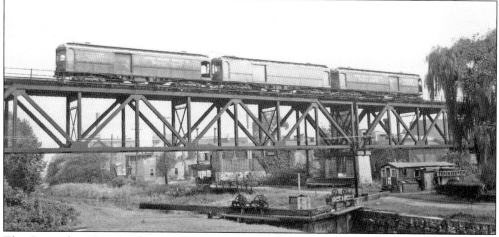

This September 23, 1950, photograph captures a three-car LVT freight train on the P&W viaduct over the Norristown Canal in Bridgeport. Although Lock 64 appears intact, the Schuylkill Navigation had not been in operation in many years. This half-mile-long reach of canal, from the Norristown Dam to Ford Street, would later be filled in. (Photograph by Lester K. Wismer.)

P&W's original Bridgeport station had the appearance of an el station. With its location high above Fourth Street at Merion Street, with no elevator or escalator to ride, the people waiting on this platform certainly got their exercise for the day. The second Bridgeport station, erected in 1957, was a simple brick shelter on an embankment 500 feet south of here. (Courtesy of Robert G. Foley.)

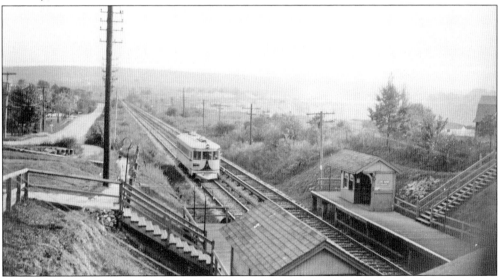

An Allentown-bound LVT Limited rockets through the King Manor station on the P&W in Bridgeport. LVT cars made only handful of stops on the P&W; King Manor was not among them. The vantage point is atop the Dekalb Street overpass. In 2010, the name "King Manor" was dropped, and this station is now referred to as Dekalb Street. Dekalb was the station's original name when the line opened in 1912. (Courtesy of the Railways to Yesterday Library.)

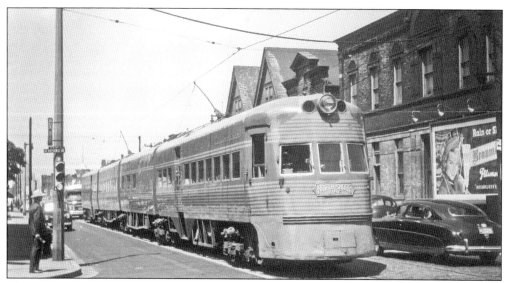

The fastest trolleys in the United States were two trainsets, dubbed Electroliners, built in 1941 for the Chicago, North Shore & Milwaukee Railroad. One of these attained a top speed just over 110 miles an hour during testing on the North Shore Line. Philadelphia Suburban Transportation Company acquired the air-conditioned trains in 1963, renaming them Libertyliners. An early plan called for electrifying the Reading Railroad Chester Valley branch and running Libertyliners between King of Prussia and Downingtown. Confined to the 13-mile Norristown–to–Upper Darby run, a dining car served pastry and coffee in the morning and snacks and cocktails in the afternoon. Both were withdrawn from service in 1977. The above photograph shows a high-speed trainset mixing with street traffic on Sixth Street at National Avenue in Milwaukee in 1949. The photograph below captures the January 26, 1964, inaugural run above Hanging Rock in Upper Merion Township. (Above, photograph by William C. Hoffman, courtesy of the Wien-Criss Archive; below, photograph by Andrew W. Maginnis.)

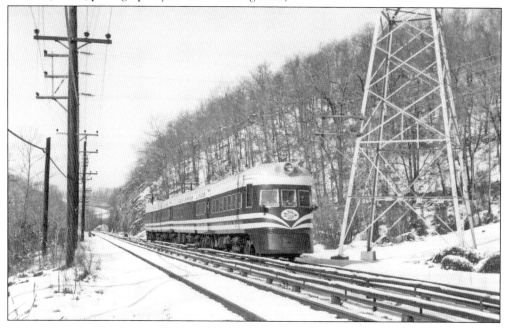

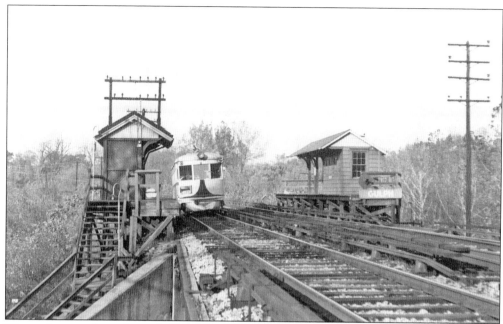

These photographs, taken a half century and a quarter mile apart, show the original and the present-day Gulph Mills stations on the P&W high-speed line. A city-bound LVT Limited passes the original station, then called simply Gulph, located where Pennsylvania Route 320 passes beneath the high-speed line. This same vantage point today would find the sky filled with the massive steel superstructure of the Schuylkill Expressway Gulph Mills viaduct. In 1954, the old station was removed and a new one built on a site north of the viaduct. Norristown–to–Upper Darby service continues today, with service furnished by a fleet of stainless-steel rapid-transit cars built in the mid-1990s. The recent photograph below captures a Norristown High Speed Line car bound for Norristown approaching the Gulph Mills station. Studies are under way to extend a branch of this transit line to King of Prussia's malls and employment centers. (Above, photograph by Lester K. Wismer; below, photograph by Dr. Richard L. Allman.)

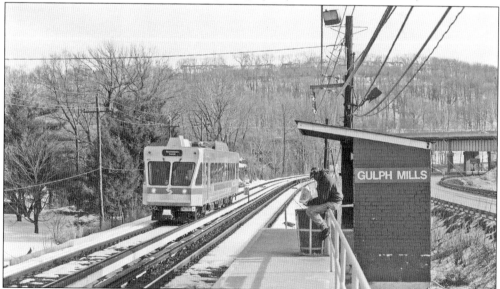

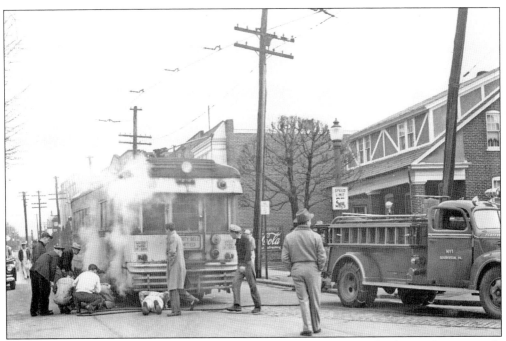

In later years, deferred maintenance took its toll on the fleet, especially the ex–Cincinnati & Lake Erie high-speed cars. They had been designed to sail across the open countryside of rural Ohio, an assignment quite unlike LVT's short sprints and frequent station stops in hilly eastern Pennsylvania. Maintenance crews sometimes referred to these cars as "mobile short circuits." Efforts are under way to extinguish a motor fire beneath a trolley on Broad Street at Penn Street in Souderton on February 1, 1949. (Photograph by Ray L. Albright, courtesy of the Railways to Yesterday Library.)

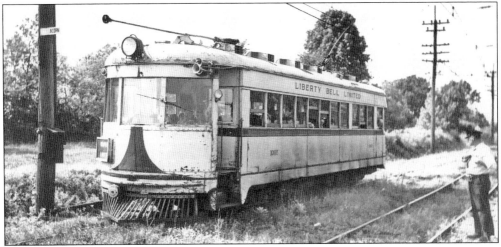

With chipped paint and its flanks browned by heat from overworked electric motors, a southbound Limited awaits a northbound at Acorn Siding near Morris Road in Whitpain Township. Only two months remained until the Liberty Bell line's autumn 1951 final abandonment. All but one of these once luxurious railcars would be towed to Bethlehem Steel and scrapped. Many of the high-horsepower electric motors, however, were removed from the cars and sold to the P&W as spares for the mechanically similar Brill Bullet cars. (Photograph by Richard S. Short.)

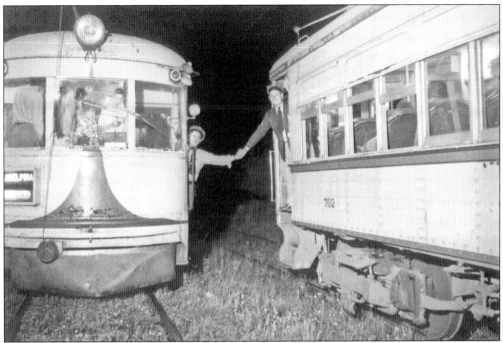

At Couter Siding along Squirrel Lane in Lansdale, car 1006 makes the very last run on the Liberty Bell line. Motorman Fred Enters (left) shakes hands with Clark Kinstler at 12:35 a.m. on Friday, September 7, 1951. The previous afternoon, LVT had received word from the Pennsylvania Public Utility Commission that permission had been granted to substitute buses for trolleys on the Liberty Bell line but only on a four-month trial basis. LVT crews began ripping up rails the next day. (Photograph by Gerhard Salomon, courtesy of David Sadowski.)

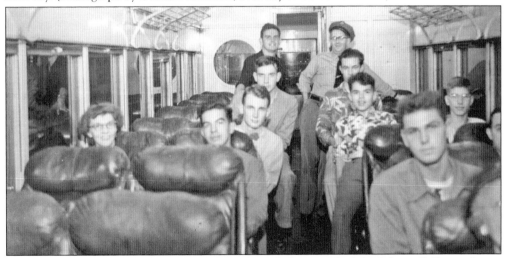

Of the hundreds of trolley enthusiasts who rode and photographed the Liberty Bell cars during their final years, only a handful received word of the abrupt end of trolley service and were able to be on hand on such short notice. This photograph records motorman Fred Enters and his passengers on the last car. After the last regular riders got off at Perkasie, Enters kindly allowed the trolley fans to take turns at the controls for the final, late-night run to Allentown. (Photograph by Gerhard Salomon, courtesy of David Sadowski.)

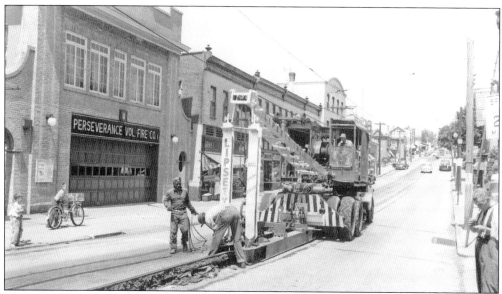

LVT wasted no time ensuring that trolleys would never run again, despite only obtaining authorization to run buses for a four-month trial period. This Autumn 1951 photograph documents rail being ripped out of the pavement on Main Street in Souderton. The Perseverance Volunteer Fire Company firehouse across the street is today occupied by the Montgomery Theater. (Photograph by Lester K. Wismer.)

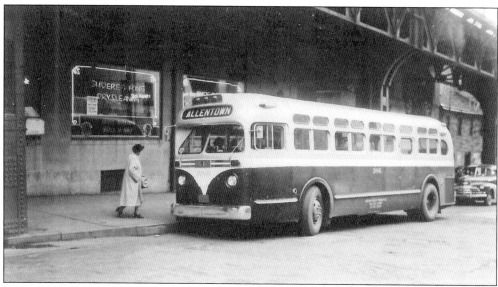

Beginning on September 7, 1951, LVT assigned buses to the Liberty Bell route. This diesel-powered General Motors coach loads passengers on Swede Street, Norristown, below the P&W trolley viaduct. These buses were slow, passengers complained, and ridership plummeted. Within a year, LVT tried substituting gasoline-powered Brill buses with manual gearboxes. The Brills were better but still no replacement for high-speed trolleys. The last Liberty Bell bus was withdrawn from service in 1956, just five years after the end of trolley service. (Courtesy of Doug Peters.)

Four

HARLEYSVILLE, SKIPPACK, WORCESTER
TROLLEY LINE FOR FARMERS

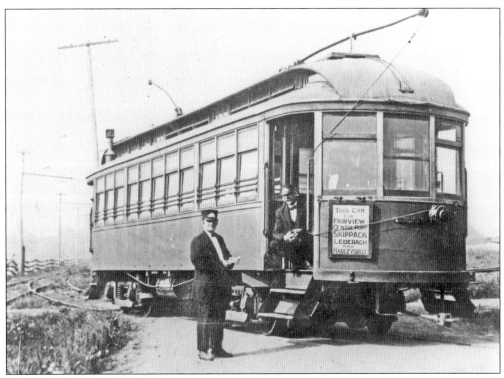

Proud crewmen Effinger and Hartman pose with a Montgomery Transit Company trolley somewhere in the countryside between Norristown and Harleysville. The location may be the side track to the stone quarry just north of Lederach. An article bearing the headline "Trolley Line for Farmers" announced the planned trolley line in the June 7, 1902, edition of the *Harrisburg Telegraph* newspaper. (Courtesy of the Wismer family.)

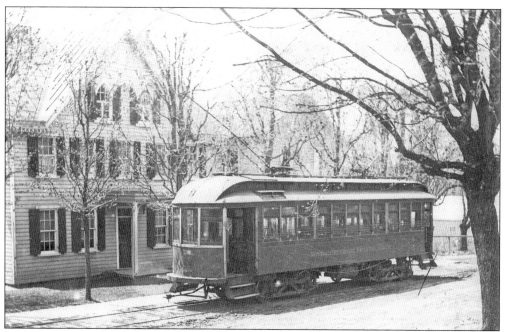

A Montgomery County Rapid Transit Company trolley waits on Skippack Pike at Collegeville Road in Skippack. Service to Skippack was inaugurated on Independence Day 1908. Eagerly anticipated for years, the *Montgomery Transcript* had this to say about the long-awaited trolley: "This is a great work: greater than mere material improvement, and no man can foretell what this newest and best convenience may lead to." (Courtesy of Pastor Paul M. Lederach.)

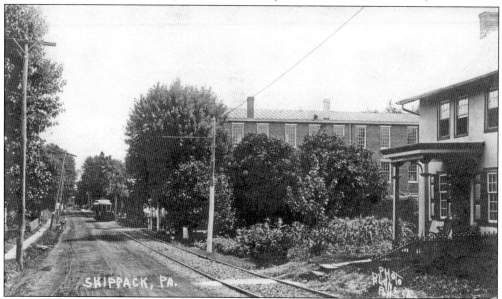

Newly laid trolley tracks suggest this photograph was made in the summer of 1912 or shortly thereafter. The photographer is looking east on Skippack Pike in the village of Skippack. The house on the right and the three-story brick building still stand. The trolley in the distance is parked in front of the trolley waiting room, behind which was located an electrical substation. (Courtesy of Jerry Chiccarine.)

This view looks north into the village of Center Point, also known as Worcester. In 1904, the Montgomery County Rapid Transit Company signed an agreement with Worcester Township supervisors to share the cost of rebuilding the road (Creamery Road, now known as Valley Forge Road) in exchange for permission to place tracks in the road. Trolley company officials had second thoughts, however, and bypassed that section of road, building this private railroad-style right-of-way instead. (Courtesy of the Wismer family.)

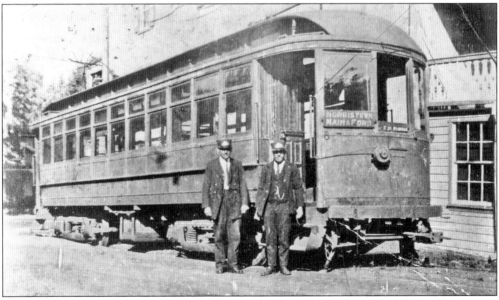

Motorman Harvey Godshalk (left) and his conductor stand at the end of the trolley line on Maple Avenue at Main Street in Harleysville. The trolley terminal, located in the street beside the Harleysville Hotel (visible to the right), was meant to be temporary. Limited earthwork was completed north of this point, but the tracks were not extended. Montgomery Transit Company's trolleys never reached Souderton, the line's intended destination. (Courtesy of the Wismer family.)

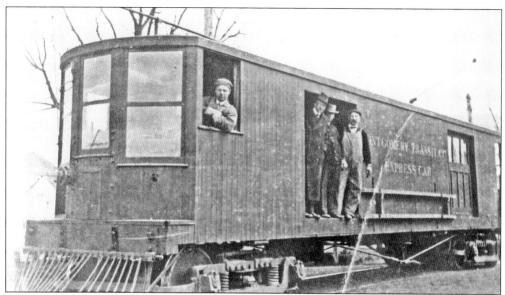

With the hauling of freight expected to provide substantial revenue to the trolley company, this large freight motor was purchased in 1912. Built by Russell Car Company, this trolley would do double duty as a maintenance vehicle. The motorman is identified as Poinsett; the man in overalls as Edward Reighter. Montgomery Transit Company's fleet included a trolley specially built to deliver stone from the company quarry north of Ledarach. (Courtesy of the Wismer family.)

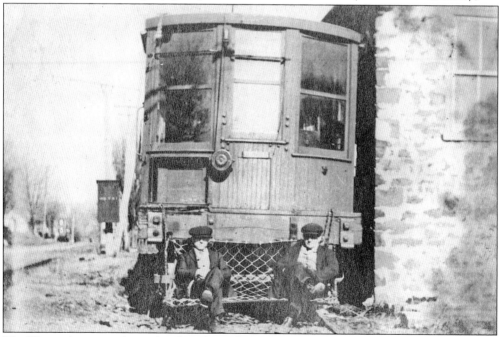

The Wismer boys are taking a break at the trolley freight house on Maple Avenue in Harleysville. Their father, H.B. Wismer, served as stationmaster, a job that entitled him to a salary of $3.50 per week. Two large doors facing the track lined up with the freight trolley's doors. After the end of trolley service, this stone building was remodeled, and it serves today as a residence. (Courtesy of the Wismer family.)

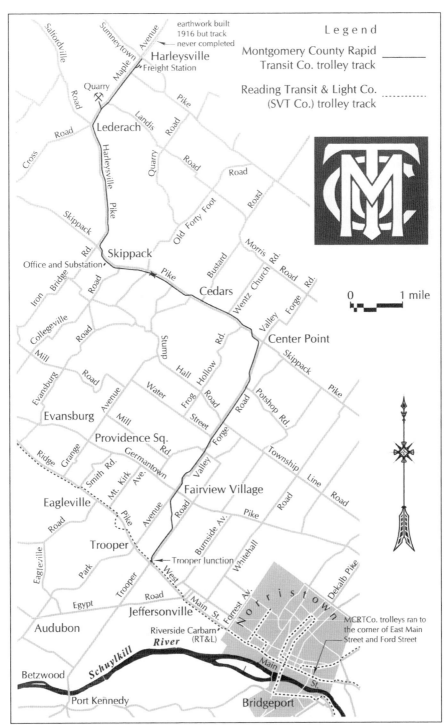

This map traces the route of the Montgomery Transit Company. Through its history, this line was also known as the Souderton, Skippack & Fairview Electric Railway; the Montgomery County Rapid Transit Company; and the Skippack & Perkiomen Transit Company. (Drafted by the author.)

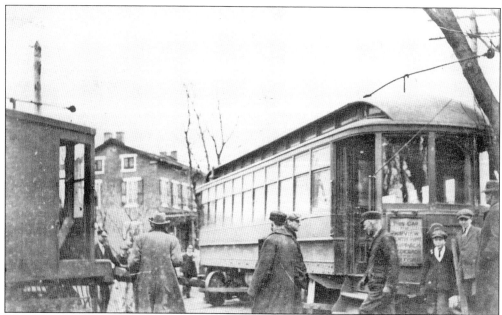

Then as now, mishaps draw a crowd. Center Point boys stand with a derailed Montgomery Transit Company trolley on Skippack Pike at a point where the trolley track swung from one side of the road to the other. The company's freight motor (left) has been dispatched to the scene. The house across the street, 3101 Skippack Pike, still stands today. (Courtesy of the Worcester Historical Society.)

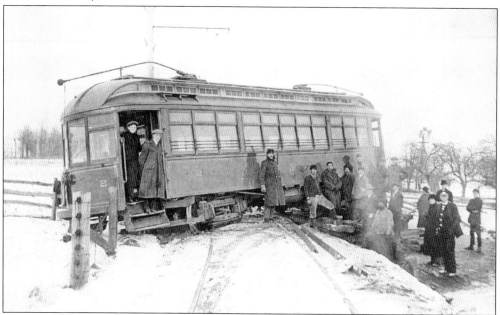

On a Tuesday evening in February 1913, a Montgomery Transit Company trolley left the rails in spectacular fashion in Worcester Township south of Water Street. The front wheels of a northbound car derailed, and the front of the trolley plunged down an embankment onto Valley Forge Road. Despite a shower of splintered plate glass, motorman Norman Hess, conductor Frank Childress, and four passengers escaped without serious injury. (Courtesy of Pastor Paul M. Lederach.)

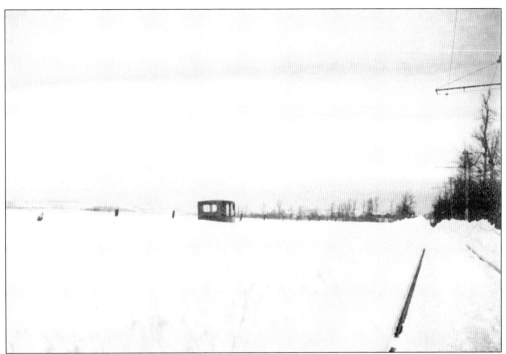

The only things moving the day after this big snow are the trolleys. This is Valley Forge Road north of Water Street in Worcester Township. Dr. H.B. Shearer, whose Ford is stranded in deep drifts, will not be making house calls to households not located on the trolley line. (Courtesy of the Worcester Historical Society.)

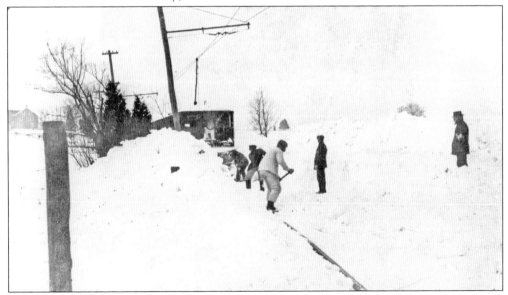

A major East Coast nor'easter in March 1914 would become known as the Billy Sunday blizzard. Fierce winds caused widespread damage; the *Ambler Gazette* reported snowbanks between four and 12 feet high. Although equipped with a steel plow, Montgomery Transit Company's freight motor derailed more than once attempting to clear the tracks. Local men, seen at the Harleysville freight station, were hired to dig out the line by hand. (Courtesy of the Wismer family.)

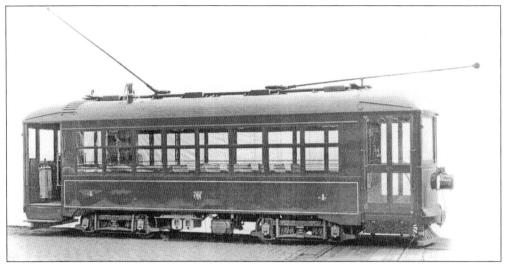

The three new trolleys purchased by Montgomery Transit Company in 1917 were painted a deep burgundy color. Built by J.G. Brill Company in southwest Philadelphia, these cars were of a unique design. Trolleys this short were usually equipped with a single four-wheel subassembly (called a truck). In contrast, these trolleys were designed as double-truck cars, which would have made them more expensive to build while improving their riding qualities. (Courtesy of Andrew W. Maginnis.)

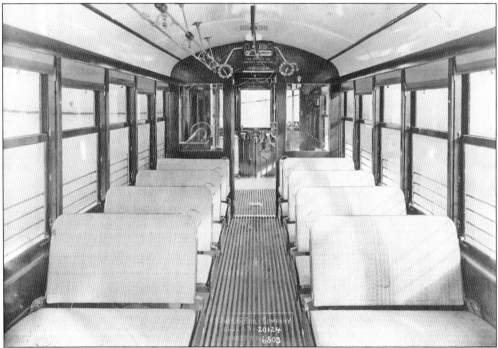

Montgomery Transit Company's 1917 cars featured bright, airy interiors. In a nod to tradition, a smoking compartment was provided. A sliding door could be closed to separate passengers from those enjoying tobacco products. As an economy measure, these trolleys could be operated by one man without a conductor. (Courtesy of the J.G. Brill Company Photograph Collection, Historical Society of Pennsylvania.)

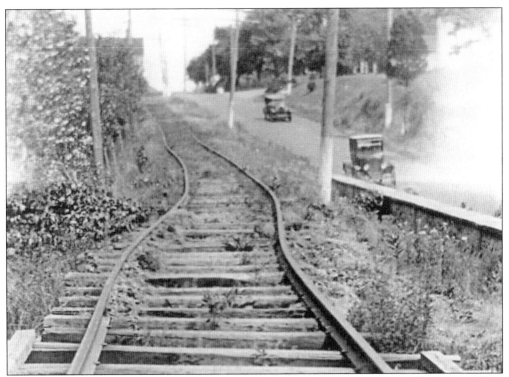

Toward the end of service, deferred maintenance had taken its toll on the trolley line, and the trolleys were referred to as "Wogglebugs." This remarkably crooked track was located across Skippack Pike from Wentz Reformed Church in Worcester Township. The copper wire and steel rails would be removed by scrap dealers in July 1925. When Skippack Pike was rebuilt as a concrete highway around 1950, both the old road and the abandoned track-bed here were buried beneath many tons of earthen fill. (Courtesy of the Worcester Historical Society.)

The view in this 1932 Pennsylvania Department of Highways photograph looks east on Skippack Pike at the bridge over Skippack Creek. By this time, the trolley had been abandoned, but the trolley bridge's concrete piers and large steel trusses over the creek remained in place. Noteworthy is the near total lack of tree cover in what was at the time an agricultural landscape. Wheat paste posters on the roadside piers advertise 25¢ vaudeville shows a bus ride away at Norristown. (Courtesy of Andrew W. Maginnis.)

The village of Skippack was home to one of the very few remaining Montgomery County trolleys. This car, however, never ran on the line through Skippack. Rather, Reading Transit & Light Birney car 511 operated in Norristown until 1933 and then Reading until 1947. At that time, the Noll family purchased it along with two others and had them moved to their property in Oley Furnace, Berks County, to be converted into living quarters. Smaller than the other two, 511 served as a shed for 30 years. Restauranteur Joseph Zameska Jr. bought 511 for use as a dining car and on June 26, 1977, had it hauled by truck to his Trolley Stop restaurant. In subsequent years, transit historian Joseph H. Frank restored 511's exterior to its original condition. When the Trolley Stop was torn down and replaced with a new restaurant in 2006, the original trolley was replaced with the carefully crafted replica on display today. In the photograph below, taken in 2013, Andrew W. Maginnis admires the replica car. (Above, photograph by Joseph H. Frank; below, photograph by the author.)

Five

WILLOW GROVE, JENKINTOWN, GLENSIDE
TAKE ANY TROLLEY TO THE PARK

Before the age of the automobile, getting the crowds to and from Willow Grove Park was no mean feat. In addition to Reading Railroad train service, no less than four trolley lines converged there. The trolley line through Glenside was among the last to run in Montgomery County, lasting until 1958. In 1948, Philadelphia Transportation Company enlisted the aid of this photogenic foursome to publicize a new fleet of streamlined streetcars for Route 6, the longest-lived of the Willow Grove trolley lines. (Courtesy of Andrew W. Maginnis.)

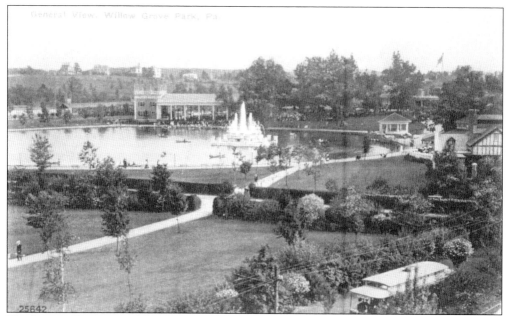

The lower right corner of this Willow Grove Park postcard includes an early single-truck trolley gliding on tracks that ran parallel to Park Avenue. In the earliest years, trolleys circled the entire park on a large loop track. The installation of the Electric Fountain in the park lake in 1896 cost $100,000. Dancing water jets illuminated with multicolored lenses made for a spectacular sight at night. The photographer's vantage point is an upper-story window of the Parkside boardinghouse, a building that still stands today. (Author's collection.)

The large multitrack trolley terminal constructed by Philadelphia Rapid Transit Company in 1905 fills this view from the top of the Mountain Scenic Railway roller coaster. Easton Road, then known as the Germantown and Willow Grove Turnpike, runs from the left edge to the lower right corner of the photograph. Ramps and a pedestrian tunnel beneath the road and under the trolley tracks connected the park and the terminal. (Courtesy of the Railways to Yesterday Library.)

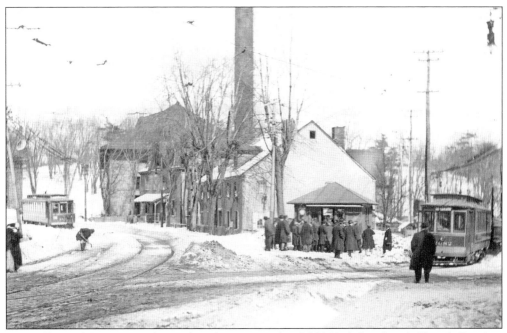

The village of Ogontz was located at the crossroads of Old York Road and Church Road in Cheltenham Township. Trolleys to Willow Grove rounded the corner to the left, while others accessed the short dead-end track on Forest Avenue on the right. PRT's coal-fired generating plant can be glimpsed beyond the houses. The group of men and boys crowding around the office may have been hired for the day to clear snow and ice from the tracks to get trolley traffic moving again. (Courtesy of the Railways to Yesterday Library.)

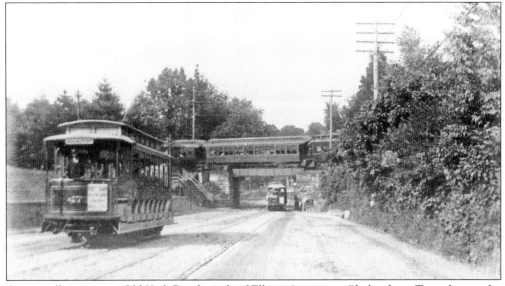

Open trolleys pass on Old York Road north of Elkins Avenue in Cheltenham Township in the summer of 1896. This is one of the few places on Old York Road where tracks were in the center of the road, the other being Jenkintown. This north-facing view also captures a Reading Railroad passenger train on the bridge overhead. Open cars were withdrawn from service after the 1918 summer season. (Courtesy of the Old York Road Historical Society.)

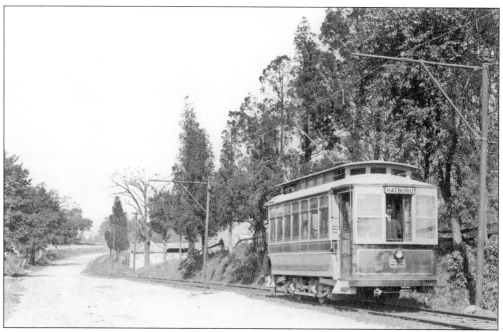

Of the four trolley lines that converged on Willow Grove, PRT's Route 74 to Hatboro was the shortest. This autumn 1909 photograph records no traffic other than a lone southbound trolley on Easton Road near Ellis Road. Today, Easton Road in Upper Moreland Township is a heavily traveled four-lane highway lined with commercial businesses. (Courtesy of the Railways to Yesterday Library.)

The Hatboro trolley line opened in 1902. Rather than build straight from Willow Grove to Hatboro on York Road, it was decided to branch off the existing Easton Road line at a point a mile and a half north of Willow Grove, then cross open fields to York Road and Byberry Road in Hatboro. This 1909 photograph documents lonely Hatboro Junction on Easton Road south of Mill Road. Today, a Sonic fast-food restaurant occupies this spot. (Courtesy of the Railways to Yesterday Library.)

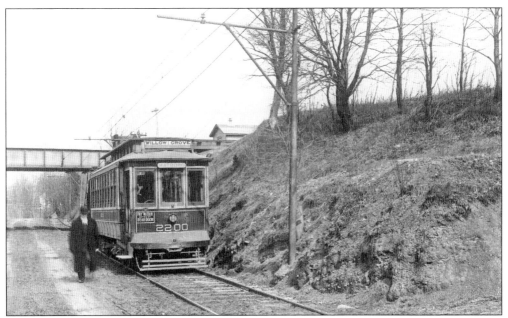

This southbound Hatboro trolley is on Easton Road at a point above Fitzwatertown Road. The Pennsylvania Railroad Trenton Cut-Off crosses on the overhead bridge. The timber structure partially visible behind the trolley contained a chute for transferring coal from railroad hopper cars to specially constructed coal-hauling trolleys. The railroad, now known as the Norfolk Southern Morrisville Line, still crosses over Easton Road today. (Courtesy of the Railways to Yesterday Library.)

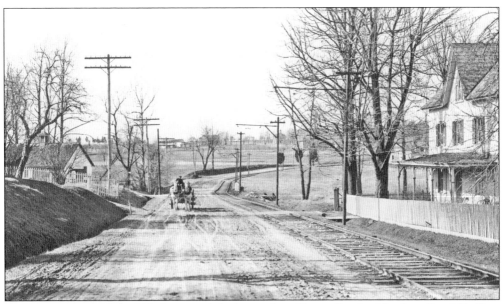

The view in this March 1909 photograph looks north on Easton Road at Horsham Road. Trolleys from Doylestown to Willow Grove used this track between 1898 and 1931. The Pennypack Creek was crossed by a bridge at the bottom of the hill. The house on the right, 368 Easton Road, still stands, albeit shorn of its porch. (Courtesy of the Railways to Yesterday Library.)

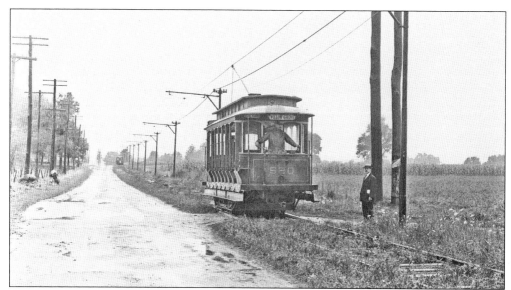

Only two trolleys and two cows occupy Easton Road in this 1907 photograph. Transit historian Harold E. Cox wondered just how well-loved these open trolleys really were. He recalled being approached by an older woman after a trolley presentation he gave years ago. She explained that she had ridden the Willow Grove open cars many times. "Bracing myself for the usual lengthy reminiscences of the past, I was surprised when she paused thoughtfully, then stated 'They rode like hell!' and walked away." (Courtesy of the Railways to Yesterday Library.)

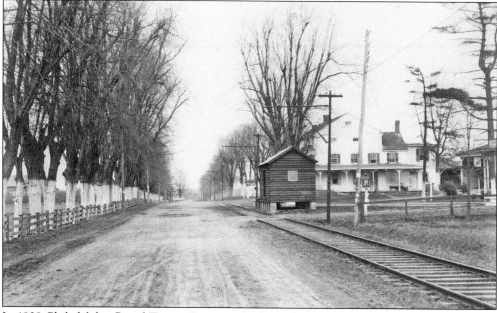

In 1909, Philadelphia Rapid Transit Company built small freight stations along the Doylestown line, including this one at Hallowell in Horsham Township. The tree-lined property on the left side of Easton Road would become Pitcairn Field and still later the Willow Grove Naval Air Station. Moreland Avenue joins Easton Road from the right, just beyond the freight station. The white plaster inn in the distance still stands, although it is closed for business. (Courtesy of the Railways to Yesterday Library.)

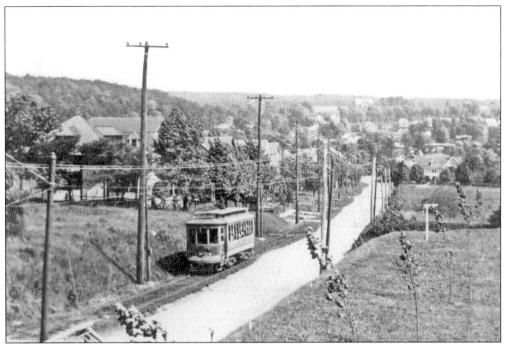

A PRT trolley from either Hatboro or Doylestown rolls down the long hill into Willow Grove. The location is Easton Road just below Barrett Road. The trolley car, built in 1906, was of a type referred to as the "Philadelphia Standard." Today, this is a four-lane highway and the roadside is nearly unrecognizable. (Courtesy of the Upper Moreland Historical Association.)

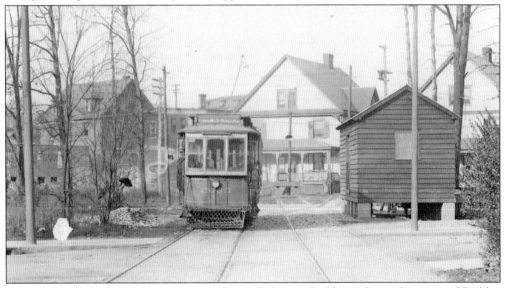

PRT's Glenside trolley freight station was located where a double-track spur line crossed Bickley Road. The spur line left the Willow Grove line at Waverly Road, followed New Street for two blocks, then turned onto a private right-of-way for the final two blocks to Glenside Avenue. Residences at 124 Bickley Road on the left and 115 Bickley Road on the right are just beyond the edges of the photograph. The houses in the background face Glenside Avenue. (Courtesy of the Railways to Yesterday Library.)

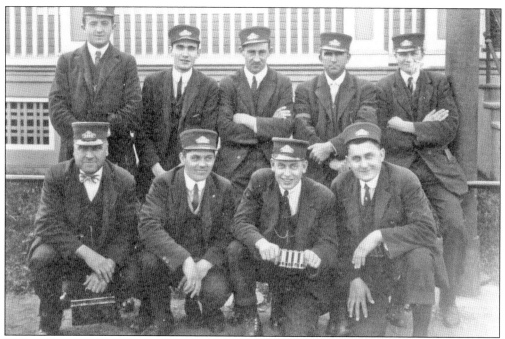

Willow Grove trolley men pose for the camera in front of the trolley office in 1913. The man on the left in the back row is motorman Louis Kuhn. His son Louis remembers, "My father worked on the Willow Grove line. He would get up at 4:00 a.m., go to work, make two trips, come home, sleep a couple of hours, then leave again at 3:30 p.m. and take the workers home for supper." Kuhn would retire in 1951. (Courtesy of Joel Spivak.)

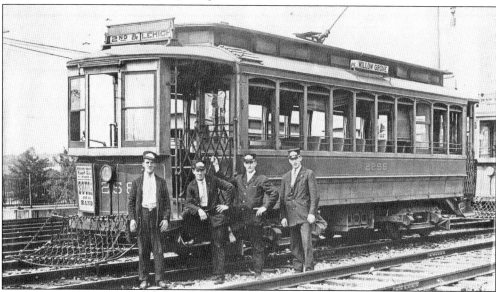

Crewmen stand for the photographer in front of PRT trolley 2258 at Willow Grove in the summer of 1912. Fortunately for the motormen, by the time this photograph was taken, these trolleys had been retrofitted with windshields. A later rebuild would add a wall with a window on this side and a door that could be closed on the other in place of the folding gates seen here. (Courtesy of Andrew W. Maginnis.)

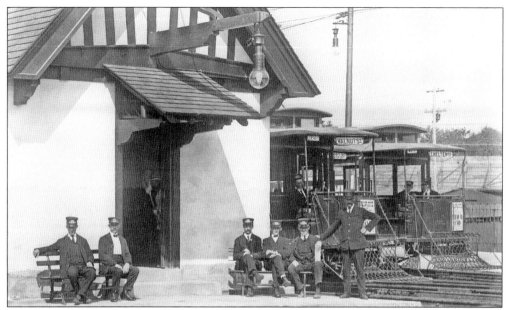

This July 15, 1905, photograph captures trolley crews resting between runs outside the new trolley terminal building opposite Willow Grove Park. As the destination signs on the trolleys imply, PRT streetcars delivered passengers to various neighborhoods in the city. When the tracks were revised in 1940, this building was lifted up, turned 90 degrees, and placed in a new location closer to Moreland Road (see page 115). (Courtesy of the Railways to Yesterday Library.)

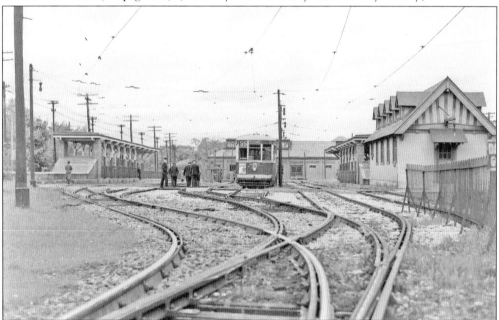

The complexity of the layout of the 1905 trolley terminal can be appreciated in this 1938 photograph. The terminal building is at right. Philadelphia Rapid Transit Company car 8051 is signed for Route 55, Old York Road. By this time, Willow Grove trolleys began and ended their runs at the Broad Street and Olney Avenue terminal in Philadelphia. (Photograph by Stanley B. Brooks.)

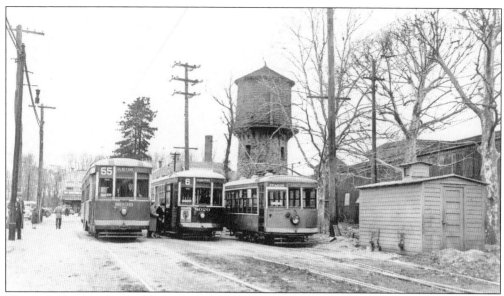

These tracks were located between Easton Road (left) and the Willow Grove carbarn (the wooden structure behind the trees). The arch-roofed building in the distance faces Old York Road. The water tower once supplied the sprinkler trolleys whose frequent passage was meant to keep the dust down on Old York Road before it was paved. The Route 55 and 6 streetcars are in regular service, but the small Birney car on the right is a visitor chartered by trolley aficionados. (Photograph by Stanley B. Brooks.)

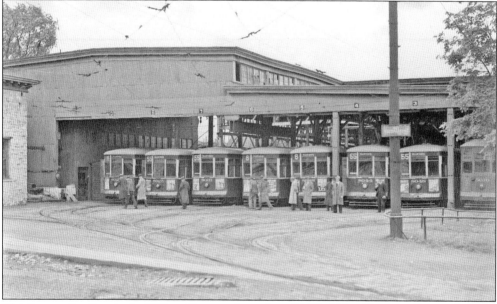

This lineup of trolleys in the Willow Grove carbarn faces Old York Road between Davisville Road and Easton Road. The wood-frame facility was built in 1895 and originally included a transfer table, a sort of rolling bridge that conveyed trolleys sideways to access nine tracks in the east end of the barn that could not be entered from outside. That portion of the barn was demolished in later years. The entire structure was razed in 1940, when Route 55 became a bus line. (Photograph by Stanley B. Brooks.)

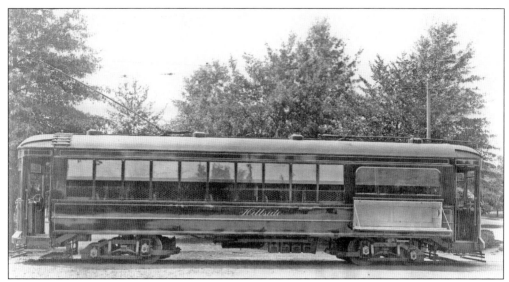

At one time, one could take every trip by trolley, including one's last. Between 1912 and 1932, PRT offered the "Hillside" funeral car, named for the large cemetery in Abington Township. The casket was placed in the trap door in the side of the car. Seats were provided for 40 mourners and six pallbearers. Harold E. Cox noted wryly that the provision of a hard wooden bench opposite the casket "presumably was to put the pallbearers in the proper somber state of mind." (Courtesy of Andrew W. Maginnis.)

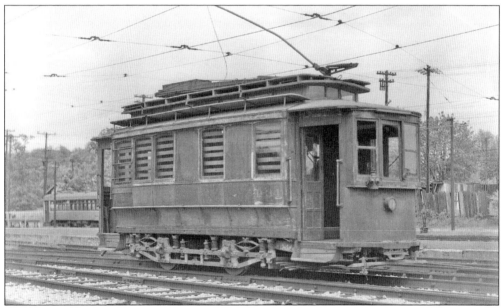

The National Railway Historical Society (NRHS) gathered in Philadelphia for its 1938 convention. On Sunday, May 15, 1938, members rode an NRHS trolley charter up the Old York Road line and toured the Willow Grove carbarn. PRT obligingly displayed ancient relics that seldom saw the light of day, including tower car D34. Built to service overhead lines by PRT in 1913, D34 started out life in 1894 as Electric Traction Company passenger trolley 48. (Photograph by Stanley B. Brooks.)

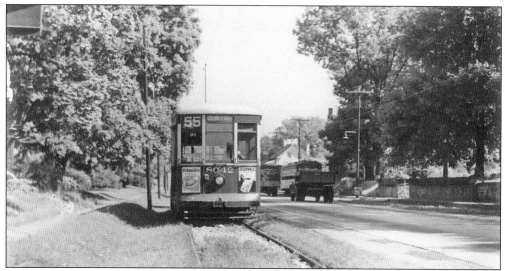

Philadelphia Transportation Company replaced the old Philadelphia Rapid Transit Company on January 1, 1940. PTC 8042 is southbound on Old York Road approaching Keith Road in Abington Township. The date is Friday, September 6, 1940. The blue-and-yellow cast-iron Keystone Marker at left was removed some time after this photograph was made. The sign's whereabouts are unknown. The trolley, however, survives to this day, housed at the Pennsylvania Trolley Museum in Washington, Pennsylvania. (Courtesy of Andrew W. Maginnis.)

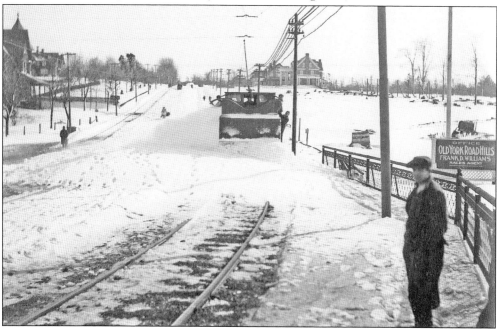

The photographer braving the cold stands on the Old York Road bridge over the Reading Railroad at the Noble station, looking south towards Jenkintown. This is the aftermath of the March 1914 Billy Sunday blizzard. The approaching rotary plow is coming north on the southbound rail. Snow is being thrown into the center of the road, which does not seem to trouble the horse-drawn sleighs. When the weather breaks, construction will resume on Rodman Avenue through the Old York Road Hills development advertised at right. (Courtesy of the Railways to Yesterday Library.)

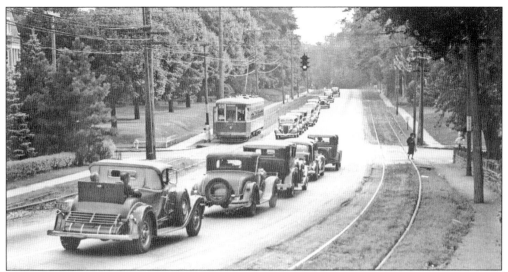

A northbound trolley pauses to discharge a passenger while motor vehicle traffic waits for the light to change at Old York Road and Spring Avenue in Cheltenham Township in 1937. The two gentlemen at left appear to be enjoying their ride in the rumble seat. The Pennsylvania Department of Highways paved two lanes of Old York Road with concrete in 1920. After the trolley tracks were removed in 1940, a four-lane road was created by paving to the curb lines. (Courtesy of the Old York Road Historical Society.)

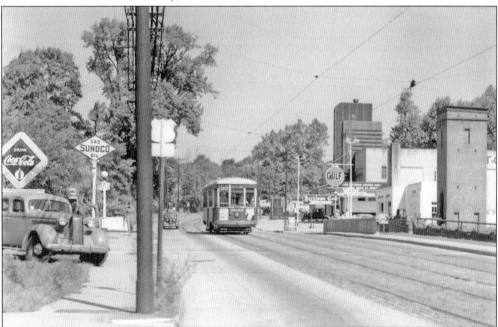

The Philadelphia-bound Route 55 trolley rolls south in Ogontz in Cheltenham Township. Prior to 1940, Old York Road and Church Road converged on this quarter-mile stretch of roadway. The brick tower and iron railing at right are part of the 1890s trolley power station. The facade of the Yorktown Theater can be seen behind the Gulf sign. Built in 1934, six years before the end of trolley service, the Yorktown would be known in the 1960s for screening foreign and art house films. (Courtesy of Andrew W. Maginnis.)

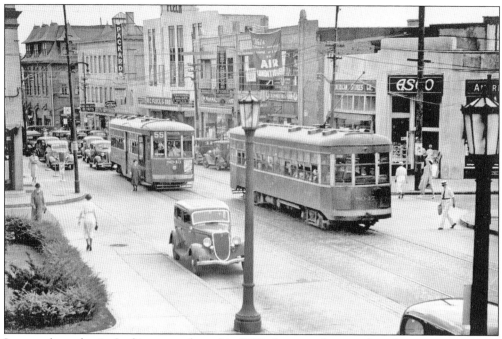

It was a busy day in Jenkintown when this 1937 photograph was taken from an upper-story window of 408 Old York Road. Two Willow Grove–to–Philadelphia trolleys are about to pass at the intersection of Old York Road and West Avenue. Although some of the facades have been remodeled, Jenkintown's business district looks much the same today. (Courtesy of the Old York Road Historical Society.)

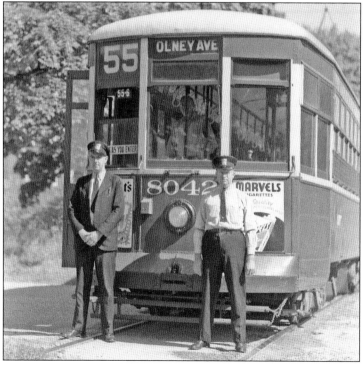

Willow Grove trolley motormen stand before a Route 55 streetcar during the last weekend of Old York Road trolley service in September 1940. Some trolley men would be retrained to drive a bus, while others would opt to transfer to other assignments operating trolleys. PTC required prospective trolley motormen to undergo training to become familiar with the various routes and types of trolleys. The possession of a valid driver's license was not a requirement. (Photograph by Stanley B. Brooks.)

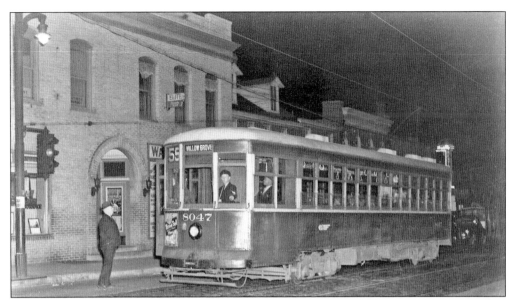

September 8, 1940, was the last day for trolleys on Route 55, the Old York Road line to Willow Grove. A planned practical joke backfired badly when local police disguised as masked gunmen "held up" what was supposed to be the last car with only officials on board. The wrong trolley was boarded by mistake; newspapers reported that three women passengers fainted in fright. This photograph, taken earlier that eventful night, captures an Old York Road trolley approaching West Avenue in Jenkintown. (Courtesy of the Old York Road Historical Society.)

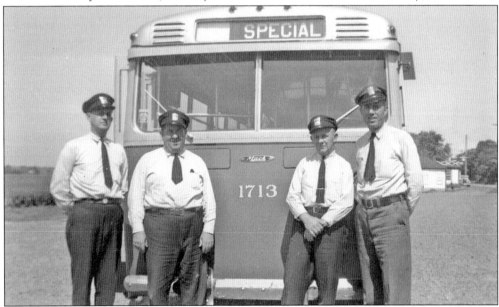

Philadelphia Transportation Company drivers stand before a new Mack model CM-3G bus at Pitcairn Field in Horsham Township. The Allentown-built Mack seated 40 passengers and was propelled by a 611-cubic-inch gasoline engine generating 160 horsepower. The three-speed manual transmission was mated to an air clutch, so there was no clutch pedal. Beginning on Monday morning, September 9, 1940, these buses provided service on Old York Road between Willow Grove and Philadelphia. (Courtesy of Andrew W. Maginnis.)

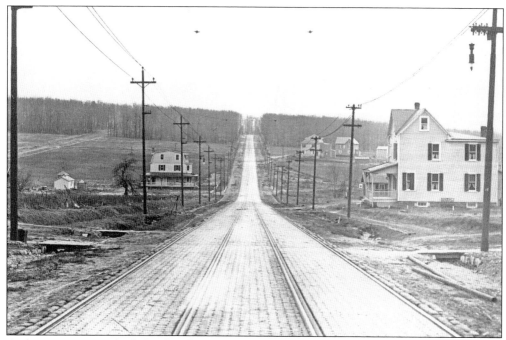

A classic streetcar suburb, Rockwell Road in Abington Township started out as a double-track trolley line; houses would come later. The 1906 view above looks south on Rockwell Road (then called Crestmont Avenue) from Rubicam Avenue. Real estate promoter William T.B. Roberts entered into an agreement with Philadelphia Rapid Transit Company whereby PRT's new line to Willow Grove would be built through several of Roberts's planned real estate developments. In the days before automobiles, proximity to a trolley line increased property values markedly. Seen below, the same Abington Township location 50 years later is a residential suburb populated by more trees, more houses, and decidedly more automobiles. The trolley was the one constant through the years. (Above, courtesy of the Railways to Yesterday Library; below, courtesy of Richard S. Short.)

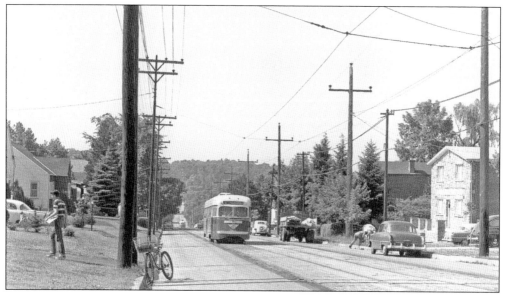

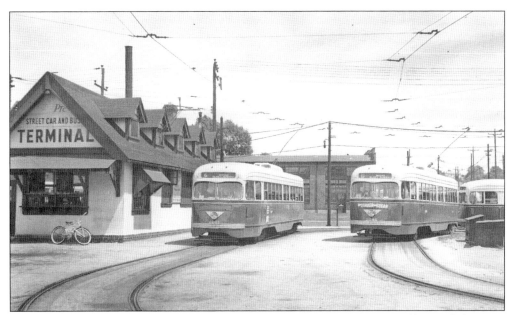

After the trolley tracks on Old York Road were removed in 1940, Route 6 trolleys ended runs at a new terminal loop built on part of the 1905 Willow Grove trolley terminal. The old terminal building (see page 107) was moved to the southeast corner of Easton Road and Moreland Road. Buses idled on the north side of the building, while Route 6 trolleys waited on the south side. This photograph finds three electric streamliners built in 1940 ready to take passengers back to Philadelphia. (Photograph by Lester K. Wismer.)

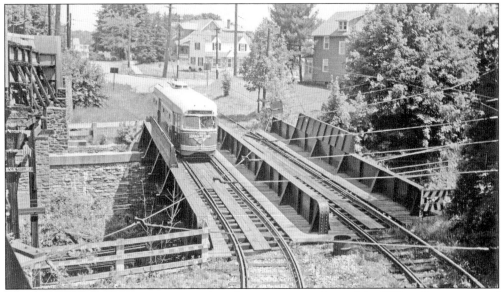

In an effort to move the maximum number of streetcars in and out of the Willow Grove terminal in 1905, an elaborate three-level crossing was engineered with two bridges and one 90-degree curve. A three-bay plate girder bridge with three trolley tracks crossed over the Reading Railroad, while another multi-span bridge carried Old Welsh Road over both rail lines. By the time this photograph was taken in the 1950s, one-third of the plate girder bridge (along with one of the three trolley tracks) had been removed. (Photograph by Richard H. Young.)

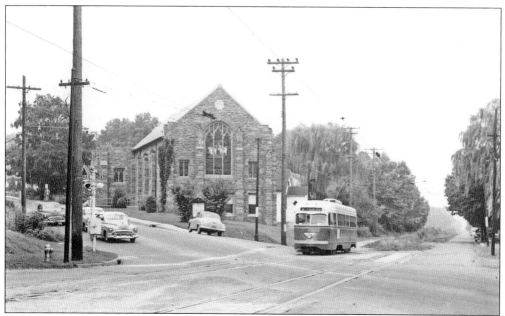

Roslyn Presbyterian Church still presides over the intersection of Tyson Avenue and Easton Road in Abington Township. On Saturday morning, July 28, 1956, northbound traffic on Easton Road has stopped at the red signal alerting motorists that a Route 6 trolley is crossing. PTC has allowed high weeds to grow between the northbound and southbound trolley tracks in the median of Tyson Avenue. The Roslyn loop, provided for turning some trolleys around, is just outside the right edge of the photograph. (Photograph by Edward S. Miller.)

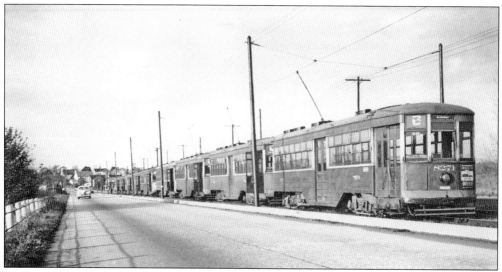

Trolleys are lined up along Limekiln Pike in Cheltenham Township during an event at Temple Stadium, waiting to take game crowds back to the city. Temple Owls football games could fill the stadium's 34,000-seat capacity. On a handful of occasions in the 1930s, the Philadelphia Eagles played at Temple Stadium, although attendance for those games was sparse. Temple Stadium was located on Vernon Road in the Cedarbrook section of Philadelphia, a 10-minute walk from the Route 6 trolley. (Photograph by Robert G. Lewis.)

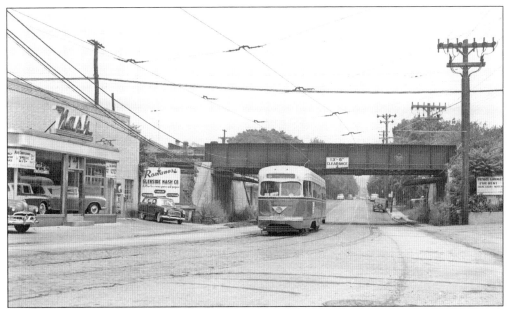

Romano's Glenside Nash showroom displays 1956 Nash cars on Keswick Avenue in Cheltenham Township. The trolley is southbound at Paxson Avenue. Glenside Avenue is behind the photographer. The plate girder bridge displays a faded Reading Lines diamond logo and today carries Southeastern Pennsylvania Transportation Authority (SEPTA) passenger trains. (Photograph by Edward S. Miller.)

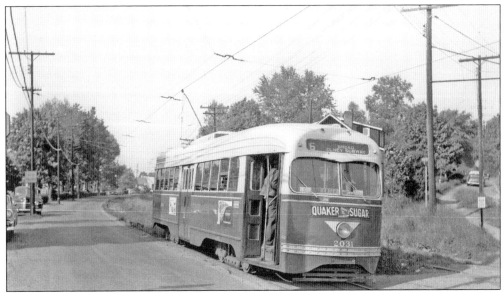

A southbound Route 6 trolley pauses to allow a passenger to climb aboard on Tyson Avenue at Edge Hill Road in Ardsley in Abington Township. Because an extra 5¢ fare was collected on northbound trolleys around the corner at Jenkintown Road and Roberts Avenue, some passengers disembarked at that point and continued their journeys on foot. This streamlined streetcar was built in 1941. The very last of this series of trolley was not retired in Philadelphia until 1983. (Photograph by Richard S. Short.)

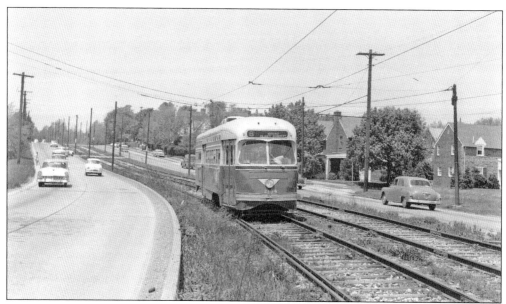

Looking very much like a modern-day light-rail line, three quarters of a mile of Route 6 trolley track occupied the median of Limekiln Pike in Cheltenham Township. Delivered in 1948, PTC 2134 heads south toward Philadelphia. On June 8, 1958, when PTC abandoned trolley service to Willow Grove, 2134 was the trolley that made the final run. Today, 2134 serves as an ice-cream stand on the 7600 block of Germantown Avenue in the Mount Airy neighborhood of Philadelphia. (Photograph by Bruce Bente.)

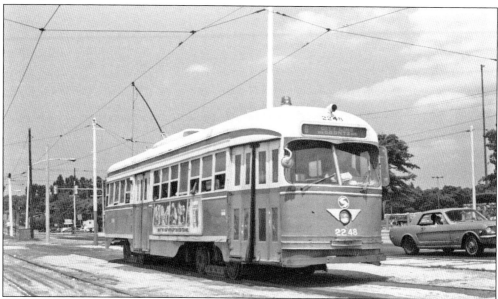

After the 1958 abandonment of trolleys to Willow Grove, the city portion of Route 6 remained an electric streetcar line. City trolleys continued to enter Montgomery County for a distance of 100 yards to access loop tracks near the corner of Limekiln Pike and Cheltenham Avenue. The trolley in this 1980 photograph served Kansas City, Missouri, and Toronto, Canada, before it was brought to Philadelphia in 1976. The remaining electric portion of Route 6 was downgraded to a diesel bus line in January 1986. (Photograph by the author.)

Six

ARDMORE
LOWER MERION'S TROLLEYS

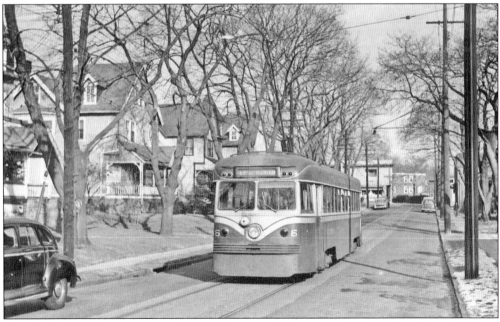

Philadelphia Suburban Transportation Company's (PST) network of electric trolley lines served Montgomery, Chester, and Delaware Counties, converging on Sixty-Ninth Street Terminal in Upper Darby. At that point, transit riders boarded Market Street elevated trains for the short ride into Philadelphia. Also known as the Red Arrow Lines, PST's Ardmore line served Lower Merion Township from 1902 to 1966. Headed for the terminal on Lancaster Avenue, Red Arrow Brilliner 6 moves away from the photographer on Lippincott Avenue. (Photograph by Bruce Bente.)

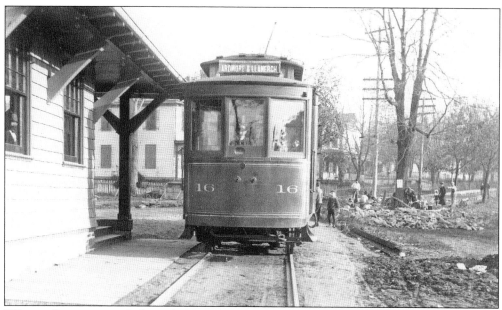

When trolley service to Ardmore began in May 1902, trolleys stopped three blocks shy of Lancaster Avenue at this temporary waiting room built on Sheldon Lane at Spring Avenue. The other end of the line was located at Sixty-Third and Market Streets in Philadelphia, where passengers boarded Philadelphia Rapid Transit Company trolleys to continue their trip into the city. After the completion of Sixty-Ninth Street Terminal in Upper Darby in 1907, Ardmore trolleys started their runs there. (Photograph by Wilbur Hall, courtesy of the Haverford Township Historical Society.)

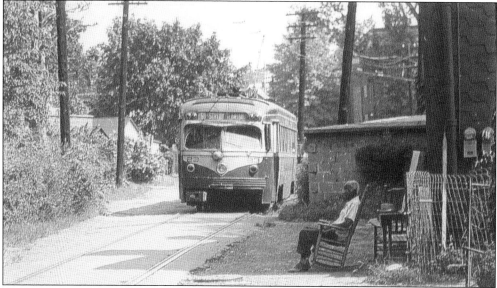

An Ardmore resident relaxes in the shade on a bright summer day on Sheldon Lane. The narrow street serves as the western edge of a compact African American enclave centered around Spring Avenue and Simpson Road in South Ardmore. Delivered to Philadelphia Suburban Transportation Company in 1949, Red Arrow trolley 23 was among the last interurban trolleys built in the United States. (Photograph by Robert G. Foley.)

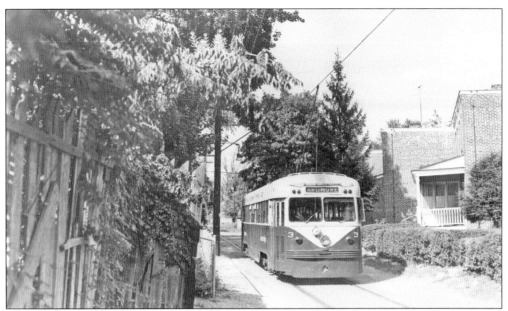

There was not much room for automobiles on narrow Sheldon Lane in Ardmore when the trolley rolled through. This August 1957 view finds a Red Arrow trolley headed for its Ardmore terminal destination. It was one of 10 streamlined Brilliners delivered in 1941, the last railcars built by Philadelphia's J.G. Brill Company. In its heyday, Brill was arguably the leading trolley manufacturer in the United States if not the world. (Photograph by Richard S. Short.)

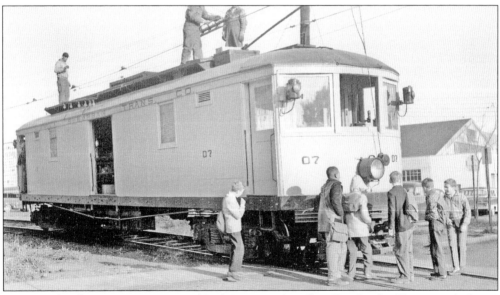

Curious schoolboys congregate around Red Arrow work trolley 07 at Cricket Terrace in Ardmore in 1966 while workmen maintain overhead trolley wire. Built by Jewett Car Company in 1911, this car started out life as a trolley freight motor. After the end of trolley freight service in the 1920s, an access hatch and roof platform were installed. Active for more than 80 years, 07 was finally retired in 1992. It was acquired by the Pennsylvania Trolley Museum in Washington, Pennsylvania, where it is displayed indoors. (Photograph by Richard S. Short.)

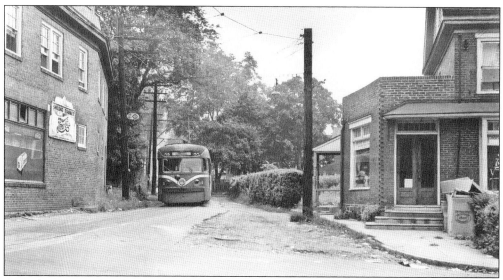

On Labor Day weekend 1949, the photographer is standing in the intersection of Spring Avenue and Lippincott Avenue in Ardmore, camera aimed at an oncoming trolley on Sheldon Lane. The half mile of Ardmore trolley line in Lower Merion Township ran in residential streets and narrow alleys such as this. However, after crossing into Delaware County, these trolleys ran on railroad-style private rights-of-way and double-track reservations adjacent to but separated from motor vehicle traffic. (Photograph by Edward S. Miller, courtesy of the W. Robert Swartz Collection, Lower Merion Historical Society.)

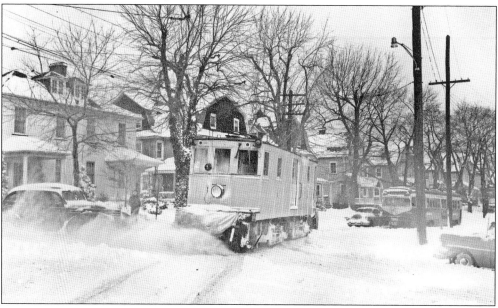

A snow sweeper clears the way for a southbound trolley on Lippincott Avenue, about to cross County Line Road. Before its purchase by SEPTA in 1970, Red Arrow was one of the last privately held public transit enterprises. In 1965, Red Arrow president Merritt H. Taylor decided to substitute buses for trolleys on the Ardmore line. Permission was granted by the Pennsylvania Public Utility Commission in late 1966. A heavy snowstorm prevented trolleys from reaching the Ardmore terminal on the last day, December 29, 1966. (Photograph by David H. Cope.)

Seven

VALLEY FORGE
TOONERVILLE TROLLEY

The Phoenixville, Valley Forge & Strafford Electric Railway entered Montgomery County for a distance of only 100 yards but at a significant location: Valley Forge. The photographer is facing west, standing at the intersection of two roads known today as Pennsylvania Route 23 and Route 252. By the time of the trolley's construction in 1912, efforts were well under way to buy up private holdings and create a state park. The four-story cotton mill visible at the left edge of the photograph was purchased by the Valley Forge Park Commission in 1919 and demolished. The old trolley in the picture would be replaced by a new one in 1915, but the trolley line itself would not last beyond 1923. (Courtesy of the Library of Congress.)

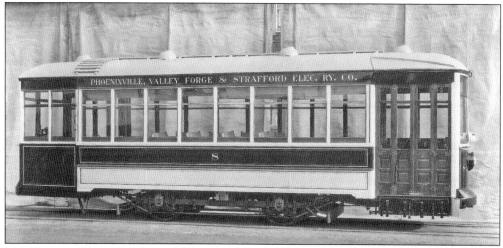

The Phoenixville, Valley Forge & Strafford Electric Railway (PVF&S) had hoped to connect with the original Strafford terminus of the P&W high-speed line, five miles south of Valley Forge. In 1915, PVF&S purchased two trolleys from the J.G. Brill Company. These were short double-end versions of Brill's patented Nearside car. Beginning in 1922, trolleys were through-routed between Valley Forge and Spring City. Strafford was never reached. The last day for trolleys was December 24, 1923. (Courtesy of the J.G. Brill Company Photograph Collection, Historical Society of Pennsylvania.)

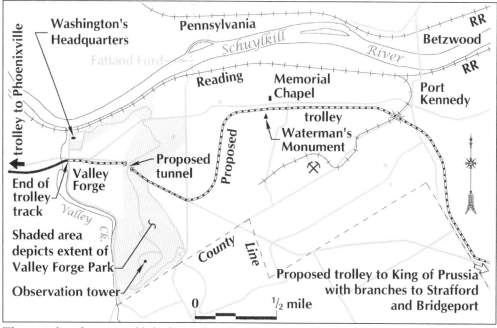

This map, based on one published in early Valley Forge guidebooks, shows the trolley line that was built (the solid line entering the park from the west) and the proposed trolley route (the dashed line). The proposed trolley line included a tunnel beneath Inner Line Drive, with the tracks to be depressed in a deep trench on either side of the tunnel. (Drafted by the author.)

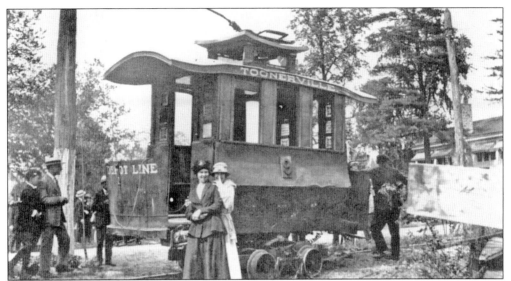

With his main studios established in North Philadelphia, silent film pioneer Sigmund Lubin built a new state-of-the-art studio along the Schuylkill River at Betzwood in 1912. The most successful of the films made here were the Toonerville Trolley series, based on Fontaine Fox's newspaper cartoons. Film crews placed facsimile Toonerville Trolleys on various railroad and trolley tracks, the PVF&S line among them. Above, the Toonerville Trolley is parked on PVF&S rails at Valley Forge. The awnings of the Washington Inn are across the street. The photograph below features actors Dan Mason in his role as the Skipper (left) and Wilna Hervey as the Powerful Katrinka (right). The location is a railroad siding at the Pennsylvania Railroad Betzwood station, which stood where the US 422 bridge crosses overhead today. The railroad here has been replaced by the Schuylkill River Trail. (Above, courtesy of Stanley F. Bowman Jr.; below, photograph by Portus Acheson, courtesy of the Betzwood Film Studio Collection, Special Collections and Archives, Brendlinger Library, Montgomery County Community College.)

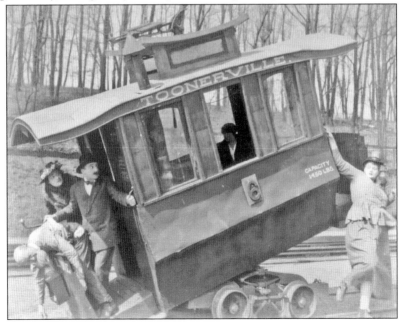

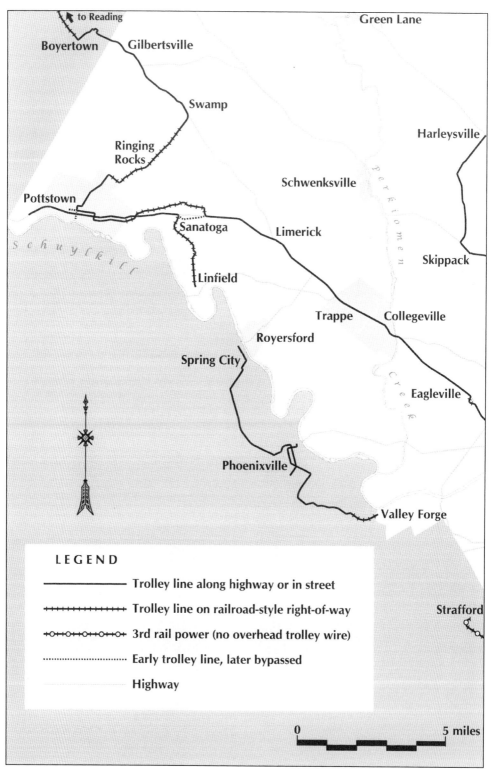

This map shows the western portion of Montgomery County. (Drafted by the author.)

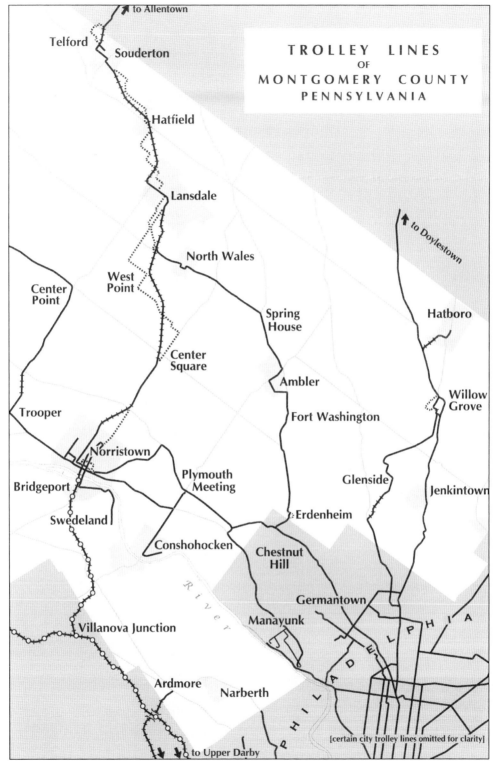

TROLLEY LINES
OF
MONTGOMERY COUNTY
PENNSYLVANIA

to Allentown

Telford
Souderton

Hatfield

Lansdale

to Doylestown

North Wales

West
Point

Center
Point

Spring
House

Hatboro

Center
Square

Ambler

Willow
Grove

Trooper

Fort Washington

Norristown

Plymouth
Meeting

Glenside

Jenkintown

Bridgeport

Swedeland

Erdenheim

Conshohocken

Chestnut
Hill

River

Germantown

Villanova Junction

Manayunk

P H I L A

Ardmore

Narberth

[certain city trolley lines omitted for clarity]

P H I L A D E L P H I A

to Upper Darby

This map shows the eastern portion of Montgomery County. (Drafted by the author.)

DISCOVER THOUSANDS OF LOCAL HISTORY BOOKS FEATURING MILLIONS OF VINTAGE IMAGES

Arcadia Publishing, the leading local history publisher in the United States, is committed to making history accessible and meaningful through publishing books that celebrate and preserve the heritage of America's people and places.

Find more books like this at
www.arcadiapublishing.com

Search for your hometown history, your old stomping grounds, and even your favorite sports team.

Consistent with our mission to preserve history on a local level, this book was printed in South Carolina on American-made paper and manufactured entirely in the United States. Products carrying the accredited Forest Stewardship Council (FSC) label are printed on 100 percent FSC-certified paper.